GHOSTS
OF
NEWPORT

GHOSTS OF NEWPORT

SPIRITS, SCOUNDRELS, LEGENDS AND LORE

JOHN T. BRENNAN

HAUNTED
America

Published by Haunted America

A Division of The History Press

Charleston, SC 29403

www.historypress.net

Copyright © 2007 by John T. Brennan

All rights reserved

Cover image: Indian Spring, now known as the Wrentham House.

All photographs by the author.

First published 2007

Manufactured in the United Kingdom

ISBN 978.1.59629.335.9

Library of Congress Cataloging-in-Publication Data

Brennan, J. T. (John T.)
 Ghosts of Newport : spirits, scoundrels, legends and lore / J.T. Brennan.
 p. cm.
 ISBN-13: 978-1-59629-335-9 (alk. paper)
 1. Tales--Rhode Island--Newport. 2. Ghosts--Rhode Island--Newport. 3.
Newport (R.I.)--Folklore. 4. Newport (R.I.)--History. I. Title.
 GR110.R4B74 2007
 398.209745'7--dc22
 2007025647

Notice: The information in this book is true and complete to the best of our knowledge. It is offered without guarantee on the part of the author or The History Press. The author and The History Press disclaim all liability in connection with the use of this book.

All rights reserved. No part of this book may be reproduced or transmitted in any form whatsoever without prior written permission from the publisher except in the case of brief quotations embodied in critical articles and reviews.

Contents

Acknowledgements

Without passion, it's only wind and water.
—Mariner's Memorial, Newport

There are so many people that deserve my gratitude; I cannot thank them all. Many people assisted me with stories. They opened their doors to me and shared their secrets. Without their openness, there would be no book.

Thanks to Melissa Schwefel and the folks at The History Press, who believed in this before it was even born, who walked me through the process and who were patient with me as I stumbled blindly in the woods.

Thanks to friends and co-workers who helped me juggle my crazy schedule to produce a book that I hope is of the highest quality. I'd especially like to thank Rick and Chris Bagley, Carol McLaughlin, Darleen Scherer, Kate Wheeler, Ginny Carico, Matthew Condon, Matthew Burke, Michael Moran, David Zatz and John Nelson.

Thanks to my wonderful family, who have always encouraged me to excel in all my endeavors. I love you and appreciate all you've done for me.

Most of all, I'd like to thank my wife, Michelle and my children, Michael, Mackenzie and Bailey. Thanks for your love, support and patience. I love you.

One

Prudence, Patience, Hope and Despair

Bound by the Sea

*'Tis now the very witching time of night, When churchyards yawn and
hell itself breathes out Contagion to this world.*
—*William Shakespeare*

Today, Newport maintains a strong tourism industry, a vibrant arts
community and a remarkable culture. Local delicacies include quahogs (a
species of clam), clam cakes (clams deep-fried in a batter), stuffies (stuffed
clams), johnnycakes (thin, crunchy cornmeal pancakes) and coffee milk
(coffee syrup mixed with milk). The local dialect is so distinct that there have
even been "Rhode Island-to-English" dictionaries published. It is fiercely
independent, perhaps due to its amazing past.

Newport's history is one of paradox; well known as a seat of power and
wealth, it is also notorious for its crime and poverty. The two have gone
hand in hand in Newport since its inception in 1639 and continue to this
very day. Wealth and power built the city, violence and crime defined it and
poverty has preserved it. Newport's well-preserved and tumultuous past is
perfectly suited for ghosts and spirits. Newport's historic legacy begins with
the political forces at work in the seventeenth century.

The founding colony at Massachusetts is perhaps one of the best known.
The Puritans, our history books tell us, came to the New World aboard
the *Mayflower* in search of religious freedom. This is not entirely true—the
Puritans were, well, puritanical and intolerant. Those whose beliefs did not
meet the exacting standards of the community were exiled or executed.

By 1636, there was a great deal of dissent within the colony. Unable to
reconcile themselves with strict Puritan beliefs, several colonists chose exile
over execution. Roger Williams was banished and settled to the south, in
an area he called Providence Plantations. Two years later, in 1638, more

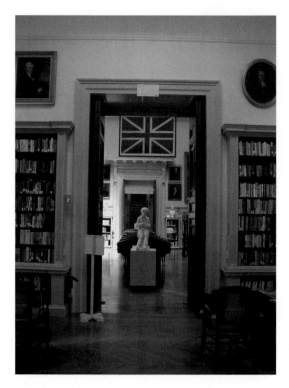

Hanging in the Redwood Library is the first flag of colonial Rhode Island, presented to Governor Benedict Arnold in 1663 and used until the evacuation of the British in 1779.

dissenters were banished. They created a settlement on the north end of the island, called Aquidneck by the local Narragansetts. The settlers purchased the island from the Narragansetts and renamed it Rhode Island.

In 1639, William Coddington and Nicholas Easton migrated southward from Portsmouth and founded Newport on the southern end of the island. Strongly believing in freedom of religion, they codified Newport's laws in the Newport Town Statutes of 1641, thereby creating one of the world's first secular democracies. By 1663, Rhode Island and Providence Plantations were united into one colony. The Royal Charter of 1663 was granted to Rhode Island "to hold forth a lively experiment, that a flourishing and civil state may stand…with a full liberty in religious commitments." No person was to be "molested, punished, disquieted, or called in question, for any difference in opinion in matters of religion." In fact, Rhode Island was the last of the original colonies to ratify the Constitution, specifically because there was not a guarantee of religious freedom. Thus, its motto became "First in war; Last in peace."

Newport became the capital of the new colony. Its liberal stance attracted a diverse population of individuals who had been persecuted in other colonies. Its deep, well-protected harbor attracted merchants and sailors

with a deep sense of independence. The city quickly grew into the fifth-largest city in the New World. Wealth came pouring into Newport, mostly through the slave trade.

Newport became a massive rum producer, with an estimated seventy rum distilleries in the city. Rum was shipped to Africa and traded for slaves. The slaves were brought to the Caribbean and traded for molasses. The molasses was brought back to Newport and distilled into rum. The infamous Triangular Trade could net a captain up to a 900 percent profit. Newport thrived.

The British Empire had many enemies—Dutch, French, Spanish and so on. In order to combat them, the colonies were allowed to dispense privateer licenses. Privateers could legally attack and plunder enemy vessels. Newport became liberal in issuing privateer licenses and many of its most influential citizens made their fortunes as privateers.

Privateering was a lucrative occupation, but could be more lucrative still if a captain chose not to limit himself to enemy vessels. Doing so was the difference between being a licensed privateer and an outright pirate. Indeed, many Newporters turned to piracy. Pirates in Newport made so much profit that local laws were written to make prosecution of pirates virtually impossible. Laws were carefully worded so that a pirate was defined as a person actively engaged in piracy. In other words, once the deed was done, the culprit could no longer be considered a pirate by law. Accordingly, nobody in Newport was convicted of piracy until the height of the British Admiralty's anti-pirate campaign in 1723.

British laws increasingly tried to reign in Rhode Island merchants. Rhode Islanders began to get hostile toward British officials. Riots broke out in Newport, with customs officials having their homes burned down. Newport even attacked British customs ships that attempted to interfere with local vessels. The British vessel *Gaspee* was attacked and burned in Narragansett Bay. All of this took place before Boston's Tea Party or the Battles of Lexington and Concord.

Rhode Island declared independence on May 4, 1776—a full two months before the rest of the colonies. The French fleet landed in Newport to help the Americans fight the British. The British soon occupied the city and laid it to waste as they evacuated following the war. Acts of vandalism were rampant; the soldiers used headstones for target practice and homes for firewood.

Newport sunk into deep poverty as the slave trade and piracy ended, with its trading partners gone and its infrastructure destroyed. The city finally had a resurgence in the 1850s as wealthy New Yorkers discovered it and created "the Queen of Resorts." The navy also made a strong presence in Newport, shaping its economy.

With its advent as a resort community, class struggle became intense. Locals were frustrated by the tourists that came in daily, starting in the 1850s. The wealthy paid the locals meager wages while flaunting their incredible wealth. "Footstools" was a nickname used to describe Newporters. Those battles remain unresolved today, as Newport still has a high proportion of homelessness and crime and among the lowest average incomes in Rhode Island.

It is a rich heritage that has been whitewashed by the tourism industry. Few people remember the riots of the 1970s, when martial law was declared. Few remember a time when some Newport neighborhoods were so bad that navy personnel were forbidden to enter them or risked being thrown in the brig. Few remember a time when Newport was so economically depressed that run-down mansions were given away or sold for as little as $25,000.

Yet these are our stories—given to us in the history books, but more so in our legends and ghost stories. Through these stories, let's attempt to relive the real history of Newport. It's much more exciting and alive than the public relations version that you have heard until now. These are the stories of Newport, Narragansett Bay and surrounding communities. A popular rhyme helps children to remember the names of some of the islands in the bay, and adequately describes its history:

> *Prudence, Patience, Hope and Despair*
> *And little Hog Island right over there.*

Enjoy your visit with the darker side of Newport.

SOUL OF A PIRATE

> *Better far to live and die*
> *Under the brave black flag I fly*
> *Than to play a sanctimonious part*
> *With a pirate head and a pirate heart.*
> —*Gilbert and Sullivan,* Pirates of Penzance

There are many reasons for a spirit to wander the earth after death. Perhaps the spirit was a horrific criminal, guilty of dastardly crimes, and has a sense of guilt weighing him down. Perhaps he died an extraordinarily slow and painful death that was also public and humiliating. Perhaps the living undertook a careful ritual designed to keep him from peace for all eternity. What if his crimes were deemed so heinous that the community felt that

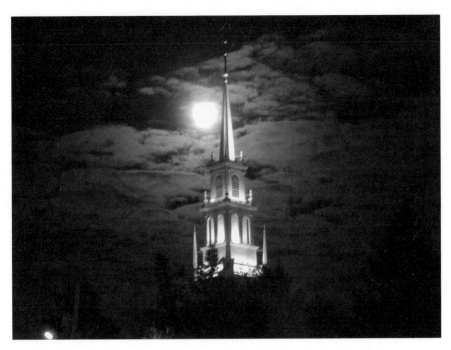

Trinity Church steeple overlooks Newport by moonlight. This was the first steeple of its kind in the New World, setting a trend in New England. Trinity Church offers one of the most fascinating of Newport's historical tours.

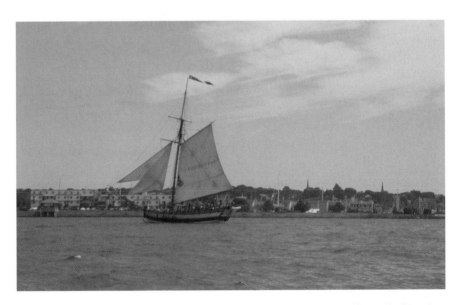

Pirates traveled on small, fast vessels like the 110-foot *Providence*, pictured here. *Providence* is a replica of John Paul Jones's Continental Sloop of the same name. It is the flagship of the state of Rhode Island.

hanging was too good for him? What if we wanted his punishment to last forever?

In the secluded islands of this earth, you may find bold settlers looking to make a new life. These men created Newport as a "lively experiment" of political and religious freedom that had never been seen before. Their liberal views were considered blasphemous and they were branded as criminals elsewhere. Their beliefs earned them the death penalty in puritanical Massachusetts. Close on their heels came a different sort of criminal, also seeking relief from persecution and prosecution. In this liberal atmosphere, such men were able to thrive and achieve prominence within the community.

Newport became particularly attractive to merchants and traders. Located halfway between Boston and New York, it has a well-protected deep-draft harbor that was perfect for the vessels of the day. Its natural climate is cool and breezy, easily propelling sailing ships on long voyages. Honest tradesmen and merchants abounded in early Newport, but there were more riches to be had in more dastardly trips.

Newport became a hub for both the Trianglular Trade and piracy. A common British tactic was to grant privateer licenses, whereby loyal colonial ships could legally plunder enemy vessels, and many Newporters became privateers. Of course, there was plenty of money to be had from loyal ships as well—if one was careful not to get caught—and many Newporters turned to piracy. So many influential Newporters became pirates in its early days that the laws were carefully constructed so that it was virtually impossible to be convicted of piracy.

But in 1723, this protection of pirates ended in a most gruesome and spectacular fashion. The British Admiralty grew weary of pirates and pressured Rhode Island to actively fight against them, or it would cease to exist. Between 1716 and 1726, over four hundred pirates were hanged in the Americas. The height of the campaign came in 1723 when eighty-two pirates were put to death. Of those, twenty-six were brutally thrust into eternity in a single execution.

It was in 1723 that two pirate sloops, the *Ranger* and the *Fortune*, were traveling together. On May 8, they captured the *Amsterdam Merchant*, captained by John Welland. On May 9, they plundered and sank the vessel. On June 6, they captured a sloop out of Virginia. They rifled the vessel and let her go. The next day, the victimized Virginian sloop encountered His Majesty's ship—the *Greyhound*, a twenty-gun vessel under Captain Solgard—and alerted the Admiralty of the pirates in the area. The *Greyhound* immediately pursued and caught up with the pirates on June 10, fourteen leagues from Long Island.

Prudence, Patience, Hope and Despair

The pirates mistook the *Greyhound* for a merchant ship and began an attack under a black flag. By the time they realized their mistake, it was too late and one of the vessels was captured. Seven aboard the *Greyhound* were wounded and the pirate vessel was brought into Newport with a crew of thirty-six. The pirates were prosecuted by John Valentine. If they held out any hope of mercy, their hopes were soon dashed by his harsh rhetoric. "This sort of Criminals are engag'd in a perpetual War with every Individual," Valentine told the court. Of these pirates, he warned, "no Faith, Promise nor Oath is to be observed." These are the sort of criminals that "every Man may lawfully destroy." Twenty-six of the defendants were convicted and executed at Gravelly Point on July 19, 1723. It remains the largest public execution in American history.

The manner of execution was short-drop hanging. Death was caused by choking, which could take between five and forty-five minutes. It is a slow, gruesome death. "The victim would be unable to breathe, and their skin would begin to turn a ghoulish shade of bluish-purple...Within minutes the tongue would protrude from the mouth, the eyes would bulge from the sockets...in many cases the prisoner lost complete control of their bladder and bowels."

The pirates were covered in tar to slow decay and the bodies were left to hang at Gravelly Point, overlooking Narragansett Bay, throughout the summer as a warning to other pirates in the area that Newport was no longer a safe haven for piracy. The bodies were finally cut down at the end of October and brought to Goat Island, where they were buried near Fort Anne, at the mark halfway between high and low tides, so the tide will forever ebb and flow over their corpses, leaving no rest for their souls for all eternity.

If you head out to Goat Island and sit along the sea wall at the Hyatt Regency Hotel on a summer day, you will see a spectacular sunset over Narragansett Bay. The bay will be filled with boats, from modern ferries to America's Cup twelve-meter yachts. As twilight extends into evening, you may feel the cool ocean breeze that has made Newport a famous sailing city since 1639. If you listen closely, it is said that you may hear the wailing of twenty-six lost pirate souls—souls deliberately entombed at this spot.

Look into the water as darkness falls and you may see glowing orbs under the waves. Are they the spirits of pirates who were purposely left to haunt the island for as long as the tide ebbs? We may never know for sure, but if you are one of the many who claim to have encountered these bizarre sights and sounds on Goat Island, you may just feel that you have made a connection with some of the last pirates to sail the Atlantic Ocean.

The twenty-six pirates executed that day in Newport were:

William Blades	Francis Laughton
John Bright	Edward Lawson
John Brown	Joseph Libby
Charles Church	Thomas Linniear
Peter Cues	Stephen Mundon
Edward Eaton	Thomas Powell
John Fitzgerald	William Read
Charles Harris	Owen Rice
Thomas Hazel	Joseph Sound
Thomas Hugget	James Sprinkly
Daniel Hyde	William Studfield
William Jones	John Thompkins
Abraham Lacey	John Waters

JAILHOUSE INN

Two men look out of the same prison bars;
One sees mud and the other stars.
—Frederick Langbridge

True to its name, the Jailhouse Inn is actually a renovated colonial prison. The property has been the site of a jailhouse since 1680. In 1772, the original jailhouse was torn down and the current edifice was constructed in the same location. The jailhouse was enlarged in 1800 and renovated in 1888. Nearly a century later, it was finally replaced.

In 1986, the Newport police finally moved its headquarters and jail to a new building on Broadway. The historic building was completely renovated to become the Jailhouse Inn. The Jailhouse Inn maintains some of the bars and design elements reminiscent of a colonial jailhouse, combined with the amenities of a modern bed-and-breakfast.

The Newport Jailhouse was not designed to be escape-proof. It was never considered particularly strong or secure. Especially early in Newport history, jail sentences were rare. Colonists preferred public humiliation as punishment for crimes. Convicts found themselves locked in the stocks in the town common, subject to humiliation and verbal and physical abuse. Those found guilty of more severe crimes were sent to the gallows. The jailhouse was designed to hold criminals temporarily while they awaited their true punishment, not as a place of punishment or reform.

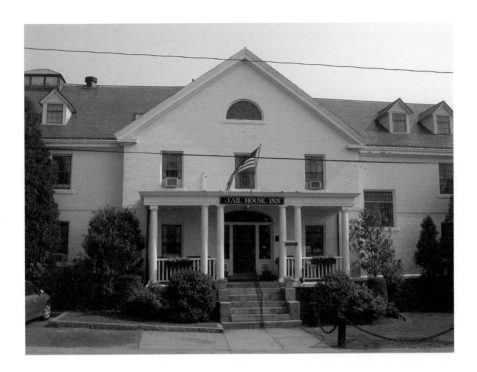

Above: America's oldest standing jailhouse has undergone many renovations to become a modern bed-and-breakfast.

Right: Heavy iron bars no longer lock guests in, but serve as a poignant reminder of the inn's historic past.

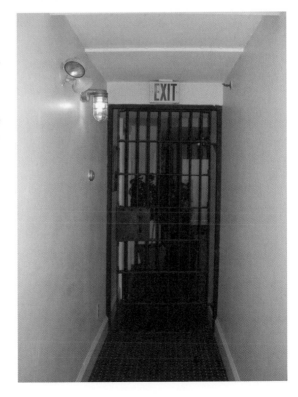

Consequently, many inmates were able to escape from the jailhouse. One of the most daring escapes involved a mason who removed the bricks from around his window during the winter of 1859. He managed to make his escape from the prison, but before he could secure a method of escaping the island, he was captured. Unfortunately for him, officials were able to trace his footsteps through the fresh layer of snow on the ground.

It seems, however, that escape is not possible for some of the Jailhouse Inn's former "guests." Over the years, many staff members have reported a strange presence, especially on the third floor. Some have reported feeling a cold breeze, even in the warm summer months. There are also reports of unexplained whispers on the third floor, leading many to suspect that the Jailhouse Inn may be haunted.

A popular saying in Newport regarding tourists who overindulge and run afoul of the law is, "Came to Newport on vacation, left on probation." If you dare make the escape attempt to Newport, the Jailhouse Inn can offer a unique lodging experience, without the unpleasantness of a criminal record!

A STREET BIDS FAREWELL

Life, how short; eternity, how long.
—Zingo Stevens, epitaph for his wife

As you enter or leave Newport via the Newport Bridge, you will find yourself on Farewell Street. Many people assume that since this is the way out of town for many tourists, we've named the street as a final message for our departing guests. The truth is that Farewell Street was so named long before there was even the thought of a bridge to cross the bay.

We are indeed bidding farewell—not to the tourists but to the dearly departed. Along Farewell Street, you will find that there are an unusually large number of cemeteries. You will pass the North Burial Ground, Braman Cemetery, Island Cemetery, God's Little Acre and the Common Burying Ground. Farther up is the Coddington Family Cemetery. The two larger cemeteries are the Island Cemetery and the Common Burying Ground. Each of these cemeteries is the final resting place of some ten thousand or more deceased individuals!

Farewell Street is not very long and the sheer number of graves gives it the distinction of having the most dead people per mile of any road in America. With thousands of dead, naturally there are thousands of stories and countless ghosts along this particular stretch of roadway. It is an old superstition that you should hold your breath as you pass a cemetery

Prudence, Patience, Hope and Despair

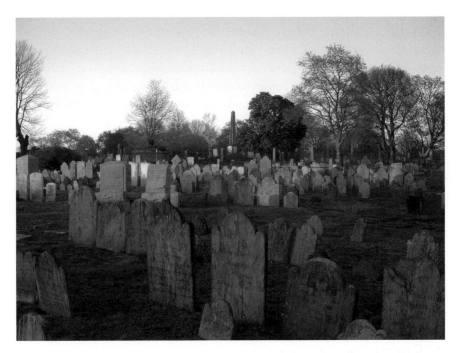

Newport's Common Burying Ground has over 350 years of history etched in stone tablets. Many more bodies are buried in unmarked graves. Either they never had headstones or the stones have been lost to time.

so that spirits cannot enter you. There are certainly plenty of spirits on Farewell Street.

One such spirit is the ghost of a man who seems lost. Locals say that his headstone was somehow destroyed or stolen and now he cannot find rest, so he wanders around nightly. Another spirit is said to patrol the cemetery looking for vandals after dark. Colonial legend has it that spirits often inhabit animals, particularly the jet-black crows that crowd the cemeteries. Witnesses have reported lights dancing upon headstones as early as 1702, the first recorded sightings of ghosts in Newport.

The oldest and largest cemetery in Newport is the Common Burying Ground. Dr. Clarke donated the land to Newport in 1640 for use as a graveyard for commoners and travelers in Newport. It was laid out in 1665 and became a major cemetery at that point. Wealthy families that owned land typically buried their loved ones in a family plot, such as the Coddington Family Cemetery farther down Farewell Street, or in church cemeteries such as the Trinity Church Cemetery in Queen Anne Square. Commoners were buried fairly unceremoniously here, giving the Common Burying Ground its name.

Given the high death rate of the area, the cemetery grew quickly. Difficult living conditions, a cold, damp climate and poor hygiene contributed to a high disease rate. Outbreaks of typhoid, cholera, diphtheria, scarlet fever, influenza, measles and especially smallpox were common. The cemetery became monstrous by the standards of the time. To simplify matters, roads were built through the Common Burying Ground and given names. Today, a modern grid system is in place to help locate specific graves, but each grave has an address as well. This address indicates both location and social status.

Newport has always been a class-based society, particularly in its early history. In town, the poor lived near the water in cold, windy and foul-smelling areas. The wealthy lived farther up the hill away from the stink of the seaport. The cemetery was set up in the same way. As Newport became more urban, even the wealthy were often laid to rest in the Common Burying Ground. Typically, they were buried back from Farewell Street, on the highest hills in the graveyard.

This is a secular graveyard. That is to say, there is no religious requirement and no restrictions are placed on occupants. This is a fairly unique concept in colonial New England, as most of the other colonies were dominated by religion and most cemeteries were run by the church. There is a wonderful expression of that uniquely secular attitude carved in stone throughout the Common Burying Ground.

Religion did play a strong role in the life of the average Newporter, and that is evident with particular diversity. One common theme of cemeteries of the time that is carried into the Common Burying Ground is the fact that most of the bodies are situated facing east. This follows the Christian belief that Christ will rise from the east like the sun to welcome all deserving souls into heaven. Bodies facing east on the day of resurrection will be prepared to respectfully face Christ upon his return.

With this Christian optimism also comes a healthy dose of Puritan pessimism that was prevalent in the area. The Puritan attitude concentrated heavily upon original sin, leaving the sense that nearly every soul was already bound to damnation. The vast majority of souls would find themselves in hell upon death, servants to Satan for all eternity. Therefore, death was viewed as a corruption of the flesh.

Bodies, particularly those of the poor, were buried in very shallow graves. Prior to the American Revolution, graves were dug only about two feet deep. Coffins were virtually unheard of; most bodies were wrapped in cloth for burial. Naturally, this became a problem as wild animals and dogs sometimes raided particularly shallow graves.

Graves were rarely given any kind of permanent marking. Stonework is a very specialized skill and there was nobody in Newport carving headstones

until 1705. Headstones prior to that date could be carved in New York, Boston or Philadelphia and shipped to Newport, but it was prohibitively expensive. Most graves were marked by a pile of fieldstones. Others were marked with simple wooden crosses, which have all long since rotted away.

In 1705, the John Stevens Shop opened and began producing inexpensive headstones for Newport. Following in his footsteps, the family continued operating the shop, training other stonecutters, such as Zingo Stevens and John Bull. The work of these men dominates the cemeteries of Newport and the surrounding area.

As the Common Burying Ground grew, a small section was devoted to slaves, free Africans and indentured servants. This northernmost section of the cemetery is known today as God's Little Acre. This is the largest surviving collection of pre-Revolutionary headstones for free Africans and slaves, containing some of the oldest examples in the country. The work of Zingo Stevens is thought to be the oldest surviving artwork signed by an African American.

The headstones throughout the Common Burying Ground show a great deal of decay. Centuries of New England weather have worn countless carvings to near oblivion. Many have been unintentionally damaged by poor restoration techniques, by improper rubbings and by other accidents. Many have been maliciously vandalized. Richard M. Bayles's *History of Newport County*, published in 1888, describes cases of "wanton mutilation" of headstones. A few had even been vandalized by British troops that occupied Newport during the Revolution. Venting their anger at the disloyal rebels, the British used the headstones for occasional target practice. Today, you can find several surviving headstones with holes created by British musket fire.

Indeed, a tour of the Common Burying Ground gives us clues to Newport's rich history. Early headstones were typically constructed of slate, a stone common to the area. Slate is a sedimentary rock and the harsh winters are particularly destructive to the carvings. Many early slate headstones are completely illegible.

Reflecting the harsh puritanical beliefs about death, many early headstones contain dark imagery. A common carving is the skull and crossbones. There are some incredible renderings of skulls that are still clear after three centuries. Later, the Puritan Death Head became more fashionable. This figure evolved from the image of a human skull with wings, to the image of a rotting corpse that would become common in the mid-1700s.

Early inscriptions contain dark warnings such as:

Behold and see
For as I am
So shall thou bee

Heavy, slow musket balls could pass through a headstone. British soldiers were notoriously bad shots; target practice was viewed as a waste of resources. It wasn't until later in the war that soldiers were allowed the luxury of target practice.

And as thou art
So once was I
Bee sure of this
That thou must die

These types of inscriptions, painstakingly carved into stone, were intended to remind the living of the harsh realities of death. It was a reminder that all sins would inevitably be judged.

As Newport's wealth and status declined, so did the headstones. Artistic quality peaked around the time of the American Revolution. Following the war, fewer residents could afford the luxury of elaborate headstones. What followed was nearly a century of austere headstones with little or no artwork. The artwork that did appear, however, became much more hopeful, in keeping with more positive attitudes about the afterlife. We find the increasing use of cherubs and willow trees on headstones, signs of hope and resurrection. One headstone even has a hand carved into it, with the finger pointing up to guide the spirit to heaven. The belief that death will reunite the spirit with God and lost loved ones in the afterlife shines through

in epitaphs such as, "I am the Resurrection and the life, saith the Lord." There is a tremendous psychological change between the phrases, "Here lies buried the body of," and "Here rests the soul of."

The urbanization of Newport began to push some influential people into the Common Burying Ground. Wealthy families no longer had the vast farmlands available to bury their dead. Family graveyards became filled. It became more desirable to bury loved ones in cemeteries away from the homestead. As influential people began to find eternal rest in the Common Burying Ground, it became more socially acceptable.

What started as a place for paupers and undesirables became the burying ground for everyone. William Ellery is buried here. A wealthy merchant and abolitionist, Ellery was one of two Rhode Islanders to sign the Declaration of Independence. Also buried here are colonial governors, merchants and clergy. Bayles's *History of Newport County* states, "One might almost write a history of Newport in this common ground, so full are the inscriptions on the stones erected there."

It's as though Newport's very soul is laid bare, carved in stone in the Common Burying Ground. There is a level of self-reflection inherent when contemplating death. Eventually, an entire lifetime of accomplishments, feelings, religion and experience must be reduced to a few words carved painstakingly into stone. What we choose to say in those few words reveals more about our culture than any history book. Upon our headstone is written our final story.

STEVENS SHOP

Here lies one whose name was writ in water.
—John Keates, epitaph for himself

John Stevens (1646–1736) moved from Oxfordshire, England, to Boston, Massachusetts, where he briefly apprenticed as a stone carver under the Mumford family. From there, he moved to Newport in 1705. He opened a small trading post at 29 Thames Street. John Stevens was about fifty-five years old when he settled in Newport.

It is believed that he did the bulk of his work in barter rather than in currency. He frequently bartered his stone-cutting skill. Stevens's skills as a stonecutter were among the worst in the New World. He worked with slate, a soft stone common on the island. While it was relatively easy to carve, it was evidently not easy for John Stevens. His carvings are crude and childlike. His lettering is uneven. His spelling is atrocious; he's even spelled the names of the deceased wrong on headstones. Due to his poor choice of materials,

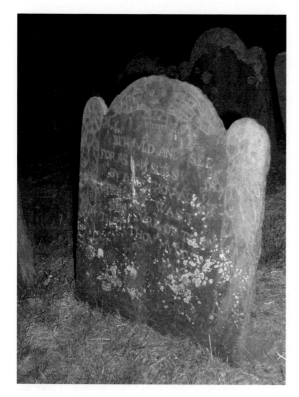

Left: This stone is meant to serve as final reminder that we are all bound for judgment in the next world.

Below: John Stevens's early work is crude but inexpensive. In spite of poor quality, his work dominates colonial cemeteries.

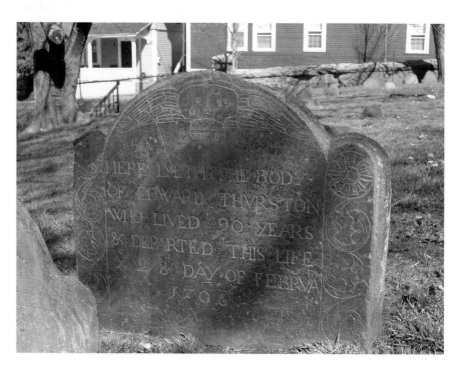

many of his carvings have been weathered away. However, because of the sheer number of stones he carved, countless examples of his work survive today, more than three hundred years later.

Given the poor quality of his work, he would have been unsuccessful as a stonecutter in Boston. Newport, however, had no stonecutter. Prior to 1705, only the very wealthy would have been able to get a stone carved for their grave. Consequently, most headstones were made of wood or were simple piles of fieldstones.

When John Stevens came to town, he found himself quite busy satisfying the demand for inexpensive, long-lasting headstones. His son, John II (1702–1778), inherited the business. He worked primarily as a bricklayer in Newport, but augmented his income by carving headstones. He and his brother William (1710–1794) produced many stones that are still legible today. Both were much more talented than their father. John II left the business to his son, John III, a very gifted stonecutter. John III (1753–1817) was the first to concentrate exclusively on stonecutting as his occupation.

Under John III, all traces of the original trading post were gone, except the stonecutting shop. As a fine master stonecutter, John III led the Stevens Shop to great success. Stevens's headstones can be found as far away as Jamaica. The final Stevens to own the shop was Edwin Stevens, who died in 1900, leaving the family business to his brother-in-law, Edwin Burdick. Mr. Burdick sold the shop to J.H. Benson in 1926; his grandson Nick runs the shop today.

Nick Benson still carves stones using the same method used by John Stevens. He works with a hammer and chisel, carefully carving each letter by hand. Today Stevens Shop stonework is highly sought after. Their work includes the National World War II Monument in Washington, D.C., as well as inscriptions at universities and museums throughout the country.

The carvings have always been a reflection of the culture. John Stevens is best recognized for his version of the Puritan Death Head. In his version, a crude human skull is flanked by wings. The Death Head signifies the angel of death come to take the soul away. Stretching up each side of the headstone is a crude swirling pattern representing the Promised Land.

Other artists of the day used the imagery of vines growing up the side of the gravestone. Hanging from the vine were fruits as mentioned in the Bible as part of the Promised Land. Particularly prominent are pomegranates. Often, artists placed two pomegranates together, stem side out, so that they resembled bare female breasts. This was a wholesome reference to mother's milk for the rebirth in the Promised Land.

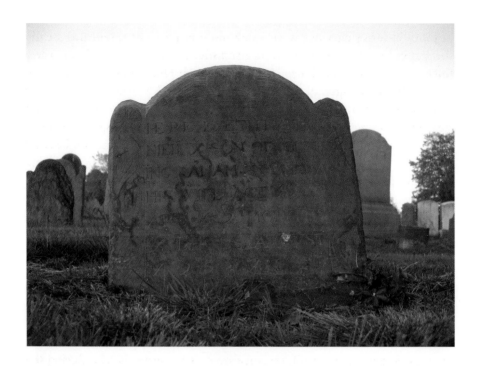

Above: Note the crudely carved figure at the top. Also, John Stevens ran out of room carving "Nathaniel," and split the name across two lines. He then spells the name incorrectly as "Nathanieiel."

Left: The Stevens family specialized in the Puritan Death Head. A gaunt figure, the head is a rotting corpse. Wings protrude from behind the figure and a scythe frames the figure, slicing through an hourglass. Time has been cut short by death.

John Stevens's carvings were much more crude. The intent was clearly the same, but the design was more stylistic. It consisted simply of a few lines and circles. John II also carved the Death Head, but one of his own design. In his images, there is a man instead of a skull. The eyes are sunken deep into the sockets and the cheeks are sunken in as well, which signifies a rotting corpse. Behind the shoulders rise the wings of the angel of death, with fine detail, showing even the feathers. Across the left and bottom of the figure runs the Grim Reaper's scythe. The scythe is slicing through the center of an hourglass, signifying that time has been cut short. Lastly, all of the sand in the hourglass has run out.

John's brother, William, was probably the better stone carver, though John is the man who inherited the business. John II worked as a bricklayer in Newport; William was more prolific as a stonecutter. His work also tends to be more uplifting. William was more likely to carve cherubs than the Death Head. His work showed a more delicate touch, with intricate, curving lines. It is William who carved the headstones for both his parents.

John III remained more traditional, deftly carving the Death Head. He was described as a frail, sensitive man and a great Patriot during the Revolution. John III is one of the men who planted Newport's first Liberty Tree. He and his family were instrumental in building Newport and subsequently recording its history in stone. Standing as a fitting epitaph for the Stevens family, their true legacy is the John Stevens Shop—the oldest continually operating business in America.

JOHN BULL

Conformity is a jailer of freedom and an enemy of growth.
—John Fitzgerald Kennedy

John Bull (1734–1808) is perhaps one of the most interesting headstone carvers in American history. Sadly, he is also one of the most overlooked. He apprenticed to the John Stevens Shop and his sister Anne married into the Stevens family. His carving technique shows the heavy influences of the Stevens apprenticeship, but makes several major departures.

Bull's work is far more extravagant than the work done at the John Stevens Shop at the time. He tended to work with a much larger stone, producing works that were grander and more flowing. His work takes on a much more optimistic tone than the dreary Stevens work. He also had a knack for making his stones more durable. To this day, a John Bull stone is more legible than a Stevens stone from the same period.

Bull has stones throughout the area, in Newport and on Cape Cod. Within the Common Burying Ground are three notable stones believed to be the work of John Bull. Two of these are very large stones, carved from sturdy slate, bearing intricate carvings and inscriptions. One is smaller, but is also an intricate carving in local slate. They are high on the hill in the Common Burying Ground, a place of great wealth and status. Perhaps, during his career, John Bull's services were more expensive than those of the Stevens Shop. But his clients were wealthy and willing to pay for superior workmanship. The Stevens clientele was most likely less wealthy and the cheaper Stevens stones are more common, thus better known to history.

In one work, John Bull inadvertently gives us a clue about colonial religious beliefs. Bull carved a stone for the Tripp children, who died young. Buried with them is their mother's arm. Mrs. Tripp was injured several years before her death; her arm had to be amputated. Mrs. Tripp joined her children and her arm many years later, in the adjoining plot. It was hoped that the body would be resurrected and the soul welcomed into heaven on the Judgment Day. The body must be properly buried to ensure that it would be available when that time came. The headstone carved by John Bull is for the Tripp children, William and Desire, and their mother's arm. The arm has its own epitaph, explaining the amputation. There is also a small carving of the severed arm in a box between the epitaphs for her children.

Another clue John Bull leaves us about colonial customs is on a very large headstone in the middle of the Common Burying Ground. Here are the remains of the six Langley children. They are all buried in a row; one headstone was eventually commissioned for all of them. For each body, custom dictates there should be a separate peak, or tympanum. The Langley stone is massive with its six individual tympanums. Each bears an identical carving of a cherub with beautiful curly hair. The epitaph lists each of the children's names in order of age. There were three boys and three girls buried there. Each boy has a different name. Each girl, however, is named after her mother. Sarah was born first, and died young, followed by a brother, Nathaniel. Then came Sarah, taking the name of her mother and her deceased sister. Another brother, named Royal, died, followed by a third Sarah, again taking the terribly unlucky name of her mother and two deceased sisters. Finally, William completes the gravesite. All six children, from a wealthy Newport household, died young, victims of the high mortality rate of colonial Newport.

The final—and most important—John Bull stone in the cemetery is that of Charles Bardin, who died in 1773. What sets this stone apart is a tremendous departure from stonecutters of the day. It is very large, very detailed and very

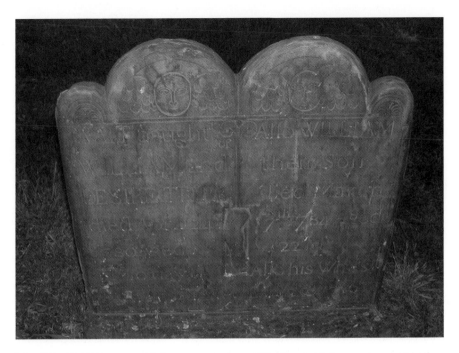

Mrs. Tripp's children rest with her amputated arm. The image of the arm is carved in the center of the headstone.

deeply carved. It is a bold carving, carved by a bold hand. On the center of the tympanum, large and clear even after more than two hundred years, is a carving of God spreading his arms to welcome the soul into heaven.

This was done in a day when others in Newport received the John Stevens version of the Puritan Death Head, or possibly a winged cherub. The idea of carving God into a headstone was unheard of. It would have been considered egotistical and, more importantly, blasphemous. John Bull may well have been criminally prosecuted. The stone would have been destroyed had he carved this in Massachusetts at the time. In Newport, he had no such fear. His carving of God is large, proud and sits on a prominent hill within the Common Burying Ground.

This may be the only carving of God ever placed on a headstone in America. Many still find it improper, a violation of the commandment, "Thou shalt not make wrongful use of the name of your God." As such, it marks a tremendous departure in Newport from the puritanical beliefs of early neighbors in Massachusetts.

There are few examples of John Bull's work today. He was expensive, provocative and artistic. His work was slower and his career was shorter than those of his contemporaries. He was forced into retirement and virtual

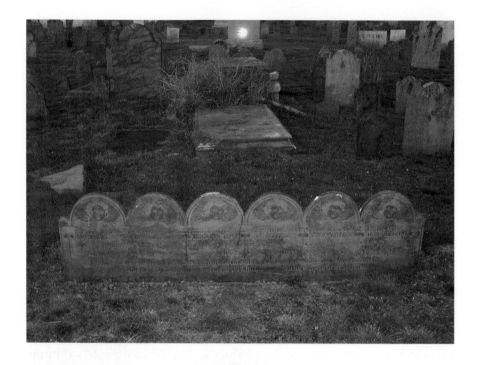

Above: Six Langley children are together in eternity. All three girls share their mother's name of Sarah. Does it show determination or lack of imagination? It definitely shows a cultural difference between now and then.

Left: God himself welcomes the soul of Charles Bardin into heaven.

obscurity when he became blind in the 1790s. However, his influence remains prominently on display, while the work of his peers and mentors fades with the centuries.

GOD'S LITTLE ACRE

Life is a shadow and a mist; it passes quickly by, and is no more.
—African proverb

The story of God's Little Acre, Zingo Stevens and slavery in Newport are intricately intertwined. One can hardly tell one story without telling the others. The first slave ship to arrive in Newport was the *Sea Flower*, which arrived in 1696. Newport's economy became dependent upon the Triangular Trade of slaves.

At that time, Newport produced the finest rum available. It was so valuable that it was used as currency on the west coast of Africa. Sadly, the rum was used to purchase slaves that were brought to the Caribbean and southern plantations. Abolitionists pointed out that Newport was adept at using slaves to make rum, stating, "You can hardly taste the blood in the rum." The slaves were traded for molasses, which was used to make more rum.

Many slaves were brought to Newport. Unlike their plantation counterparts, they were not laborers. The slaves in Newport were generally skilled craftsmen, apprenticed young to Newporters so that they would learn English as well as a trade. Their skilled labor helped build Newport. It also afforded them more opportunity.

A skilled laborer could, in Newport culture, work for wages when his duties were completed. With only a few slaves per household, slaves became a part of the family in many ways. They were not mistreated, partly because of this relationship and partly because of their value.

Newport developed a fairly unique slave and free black culture. One slave was named Zingo Stevens. As was customary in Newport, he took the Christian name of his masters, the stonecutters of Newport, and used his African name as his first name. Zingo apprenticed as a stonecutter and worked on stones for African residents when his duties were done. His first wife, Phyllis, was owned by Josiah Lyndon. When she died, the Lyndon family commissioned a stone from Zingo.

He had time to carve, and the stone is intricate. Phyllis's image is carved on the stone, dressed in traditional African dress. She cradles the child that is buried with her. She is believed to have died in childbirth and the child did not survive long afterward.

Zingo continued to carve stones for slaves and free blacks, and eventually remarried. At some point, he was able to obtain his freedom, but Zingo's sad ordeal was far from over. His second wife, Elizabeth, died and was buried next to his first wife. He carved her stone as well, without the contributions of a wealthy benefactor. The second stone is much less ornate.

Zingo took a third wife, Violet, while in Newport; she is also buried under a plain marker that Zingo carved for her. Newport's wealth was gone at this point. The final stone is the most plain. Zingo is believed to have left Newport for Providence, and was never heard from again.

Zingo leaves an interesting mark. His wives are buried on the north side of the Common Burying Ground, in an area known as God's Little Acre. It is the oldest and largest colonial African cemetery in the country. Zingo's work is the oldest surviving signed artwork by an African American. Not only is his work visible in the graves of his wives, but also in the graves of his brother and countless others who are buried in God's Little Acre.

ISLAND OF DEATH

We live on a placid island of ignorance in the midst of black seas of infinity, and it was not meant that we should voyage far.
—H.P. Lovecraft

Rose Island sits just off the coast of Aquidneck, one of many smaller islands that fall under the jurisdiction of Newport. It was used as a fort as early as the late eighteenth century to defend against the British. The barracks of Fort Hamilton were built between 1798 and 1800 to be cannon-proof. The 210-foot-long brick structure has walls more than 3 feet thick to protect troops from bombardment.

During World War II, more than 80 percent of all torpedoes used by the United States were built in Newport. The navy took advantage of the bombproof nature of the barracks to store explosives. It is said that enough explosives were stored in the Fort Hamilton barracks that, had there been an accident, the ensuing explosion would have shattered windows as far away as Fall River, Massachusetts.

In 1870, the lighthouse was first lit as a navigation aid on Narragansett Bay. The lighthouse served as a beacon for over a century before it was finally abandoned in 1971. By then, the Newport Bridge had been built and had replaced the Rose Island Light.

Over the next decade, vandals and weather took a toll on the structure. In 1984, the lighthouse was declared surplus by the U.S. government. The non-profit Rose Island Lighthouse Foundation was created to preserve

Above left: Phyllis Lyndon, slave to Governor Lyndon and wife of Zingo Stevens, is buried with her son, Prince. Her image in traditional African dress, holding Prince, adorns her grave.

Above right: Zingo's second wife, Elizabeth, is buried with her stillborn daughter. Governor Lyndon financed Phyllis's headstone. Elizabeth's stone is more traditional and inexpensive.

Right: Zingo's third wife is buried under a plain marker. This is probably a reflection of the post-Revolutionary depression that Newport was suffering from.

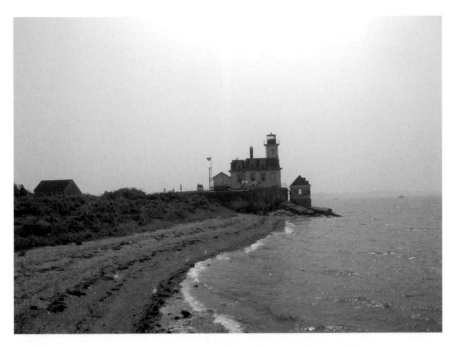

Rose Island Light serves as a beacon to shipping and a haven of tranquility.

the historic light. By 1993, after nearly a decade of backbreaking work by countless volunteers, the Rose Island Light was once again lit as a beacon to shipping on Narragansett Bay.

The Rose Island Lighthouse Foundation owns most of the island. Visitors are allowed on the beaches for most of the year, but there is no trespassing into the interior of the island. The island still holds several abandoned military structures dating back to World War I and World War II. These are dilapidated and unsafe, filled with birds and toxic bird guano. This portion of the island is a bird sanctuary closed to visitors April 1 through August 15, during seagull nesting season.

The Fort Hamilton barracks, the largest and oldest military structure on the island, is open to visitors thanks to careful restoration efforts on the part of the Rose Island Lighthouse Foundation. The lighthouse is owned by the city of Newport and maintained by the Rose Island Lighthouse Foundation. The lighthouse has been painstakingly restored to its turn-of-the-century glory.

Cooled by sea breezes and accessible only by boat, Rose Island is a calm oasis from the bustle of Newport's summer tourism. In the summer months, visitors may board the Jamestown Ferry, which makes regular stops at Rose Island. After a relaxing voyage on the oldest ferry service in America, visitors are transported to a simpler time on a remote island.

Prudence, Patience, Hope and Despair

The island has no services from the mainland. The island has no water supply, no electric lines, no phone lines and, of course, no cable. It is a completely self-sufficient property. Water is supplied by a cistern in the basement, which collects rainwater for use at the lighthouse. A wind generator supplies electricity, but there is little need for it. There are no major appliances, no television and no stereo. There is an antique hand-cranked phonograph machine and a hand pump for water, as well games for the families that stay there. There are also chores that need to be done.

There can be a long waiting list for guests who wish to stay at the Rose Island Lighthouse. Some choose to stay for just one night as guests; others choose to spend a week on the island as keepers. Keepers get training in the day-to-day maintenance and operation of the lighthouse and have private quarters on the second floor. The relaxed pace of the island makes vacationing there a remarkable, bonding family vacation. Instead of TV and hectic sightseeing, families hike, work together doing chores, fly kites and play games. Without the interference of technology, they talk and tell stories. The island closes to all but keepers and overnight guests in the evening, giving unparalleled peace in a picturesque environment.

It seems almost impossible to imagine that the island has had a tumultuous history. Untold numbers of people have died on the island; mass graves lie lost in the wooded areas in the bird sanctuary. From its earliest history, the island was used to store explosives and as a rifle range by the navy. There are no records of the number of men who were accidentally shot to death or blown to pieces on the island, though it is known to have been a frequent fact of life.

The military also used the island to bury soldiers. In 1938, just before the destructive hurricane of that year, a water tower was built on the island. As workers dug to install plumbing from the tower, they uncovered a lost military cemetery. Keeper George Bell reported that they found human skeletons. The remnants of clothing bore what he thought resembled Civil War-era buttons. The remains and artifacts were placed in a large metal box and reburied at an unknown location on the island. They have never been found.

In 1823, a major cholera outbreak struck Newport. Not fully understanding the disease, residents used the Fort Hamilton barracks as a quarantine location for those suffering from the disease. During the epidemic, countless Newporters did not survive and were buried in a mass grave on the island. Again, the location of this grave is today unknown. In fact, there may be other mass graves on the island, as it was used for quarantine through many epidemics. Newport suffered frequently from disease outbreaks because of poor hygiene and ineffective medical practices.

Newport saw outbreaks of smallpox, cholera, typhoid, tuberculosis and influenza, among others. The problem was exacerbated by the number of travelers Newport attracted from overseas and across the country. Nobody knows how many mass graves may be hidden in the bird sanctuary.

Newspaper accounts even report that "ghouls" stole bodies from the island in the late 1800s. Lighthouse keeper Charles Curtis's son witnessed the theft and reported it to authorities. Most likely, the bodies were stolen for medical research. Perhaps they were navy sailors who died in an accident and were buried on the island by the navy. Unfortunately, even their simple, unmarked graves would be desecrated in the name of research.

There are several confirmed ghosts that dwell in the lighthouse. One ghost is that of lighthouse keeper Charles Curtis who served thirty-one years beginning in 1887. Overnight guests claim to have heard him walk down the stairs at midnight, as was his custom in life, and make a thorough inspection of the facility. He makes a brief stop in the kitchen before returning upstairs for the evening. One guest took a photograph of a picture that hangs in the lighthouse—a John Philip Hagen painting in a glass frame. Clearly reflected in the glass of the frame is the image of Charles Curtis himself!

Curtis's grandson, Wanton Chase, was instrumental in restoring the lighthouse to the way it stood in 1912. His memories have, as much as possible, recreated the feel of the light at the turn of the century. His recollections have also gone into a book, *Boyhood Life at Rose Island*. Chase was "a very sickly baby," who was sent to live on the island with his grandparents in the hopes that the salt air would help. He vividly remembers life on the island and even includes a recipe for his favorite dessert, sea moss pudding. Made from white seaweed, "it was sort of round, about the size of a softball."

An antique kitchen wood stove was donated to the foundation during renovations. Wanton Chase was brought to the island to help assemble it from memory, but by the time he arrived, the keeper had managed to get it put together. According to a witness, "As soon as Want saw the stove, he turned white as a sheet. 'What's wrong,' I asked. 'Can't you see her?' 'See who?' 'My grandmother, standing in front of the stove!' Suddenly, everyone in the room caught a whiff of sugar cookies!"

Today, you can visit the Rose Island Lighthouse for a day, a night or a week. Share in the history, the beauty and the tranquility of a lighthouse frozen in time at the turn of the century. Share the history with the ghosts of Wanton Chase's grandparents, Charles and Christina Curtis, at home forever on their island paradise in Narragansett Bay.

World War II ruins are being reclaimed by nature. Somewhere here is a mass grave from a cholera epidemic. Victims of other epidemics and military men who died in Newport are also buried here. Nobody knows where the bodies are today.

BEYOND SALVATION

Does anyone know where the love of God goes
When the waves turn the minutes to hours?
—Gordon Lightfoot, "The Wreck of the Edmund Fitzgerald*"*

One of Newport's most scenic drives is known as the "Ten-Mile Drive." It starts at Wellington Avenue at Thames Street and winds along Ocean Drive, returning downtown along Bellevue Avenue. Along the drive are some of Newport's most spectacular mansions, Hammersmith Farm, Fort Adams, the New York Yacht Club and Brenton Point State Park. Brenton Point has long attracted sightseers, particularly during storms. The deep Atlantic meets the rocky reef here in breathtaking beauty. During storms, violent ocean waves crash into the seawall at high tide and are shot high into the air. They crash down upon Ocean Drive in a spectacular rain of seawater, seaweed and sometimes rocks and other debris.

Brenton Reef has claimed countless vessels over the years. Wrecks lie strewn about the reef, sometimes piled atop each other. Jagged rocks, fierce

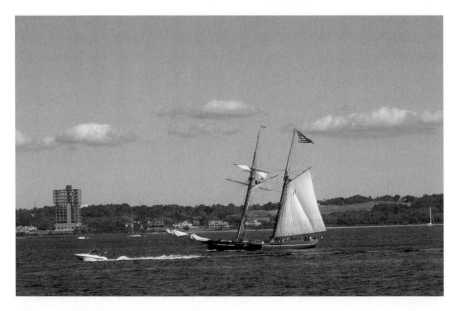

Minerva was a small two-masted vessel like the one pictured here, sailing in Newport Harbor.

currents and low visibility make the remains of these wrecks some of the region's most dangerous dives. The intense energy of the sea at Brenton Reef has reduced most of these shipwrecks to half-buried debris fields of cannon and wrecked cargo. Untold numbers of men, women and children have perished in the dangerous waters around Brenton Reef. Vessels can easily become disoriented in the thick fog that can blanket the area. Powerful currents and waves can dash even the largest ship to pieces on the rocks that lurk just beneath the surface. So many bodies were pulled from this particular stretch of coastline, that it was commonly known as Graves Point.

One such shipwreck leads to a strange Newport legend. During the Revolution, Jahleel Brenton remained a loyal Tory, and one night was entertaining a British officer named Lieutenant Jared Stanley. Brenton had an adopted daughter living with him at the time, whom he had named Alice. Lieutenant Stanley commented that young Alice strongly resembled his sister, Beatrice Stanley. Alas, poor Beatrice had been lost at sea fifteen years earlier. In one of the great coincidences that can only become legendary, Alice had been the sole survivor of a shipwreck on Brenton Reef, too young to know her real name. Brenton's adopted daughter, Alice, was none other than Stanley's lost sister, Beatrice!

Perhaps the worst wreck at Brenton Reef, however, was the Spanish brig *Minerva*, which sank on Christmas Eve in 1810, taking ten souls with her. In one of the most violent northeasters ever recorded, with hurricane-force

winds and fierce blinding snow, the *Minerva* was driven into the reef. The fury of the storm made it impossible for those ashore to render assistance to the brig as it was torn up on the rocks.

Vessels of the day customarily carried minute guns aboard, which were fired every minute during a disaster to signal for assistance. Unable to assist, Newporters could only listen with horror as the *Minerva* was torn apart on the reef that night; her desperate plight echoing through Newport with each cracking retort of her minute gun. Eventually, the grinding of her hull, the screams of her crew and the heart-wrenching sound of her gun were silenced forever as she finally succumbed to the savage sea.

Pulled from the sea that night were three pipes of rum and eight casks of Catalonia wine, nine surviving crewmen and three bodies. Wreckage continued to wash ashore for days afterward. An attempt was made with a diving bell to recover some of her cargo, but efforts proved fruitless. Her cargo—gold, silver, commodity metals and coins—is a treasure that remains lost, in just twenty feet of tempestuous sea, on Brenton Reef to this day. In fact, the 214-ton, 146-foot fishing vessel *George W. Humphreys* struck the same reef and sank into the wreckage of the *Minerva* on July 6, 1904. Like the *Minerva* of nearly a century earlier, the savage seas and jagged rocks have reduced the vessel to a scattered field of debris and artifacts wedged into the rocks.

Some say that if you venture to Brenton Point—particularly during a northeaster and especially on Christmas Eve—the ghost ship *Minerva* can still be heard struggling in the dark. Some claim to hear a harsh grinding noise. Others claim to hear the loud, regular crack of gunfire coming from just offshore. Still others swear that they hear on the wind the low, mournful cry of the sailors who perished at sea a century ago.

ACCUSATION FROM THE GRAVE

There is no witness so terrible, no accuser so powerful as conscience
which dwells within us.
—*Sophocles*

Rebecca Cornell of Portsmouth, Rhode Island, died on February 8, 1672. She was discovered alone in her room, burned almost beyond recognition. She had been elderly by colonial standards, about seventy-three years old. It was a cold winter night and Rebecca's son had last seen her smoking a pipe in front of the fire. Perhaps a spark from the fire ignited her clothing; perhaps it was her pipe that brought about her demise. Accordingly, the coroner ruled her death "an Unhappie Accident

Frigid temperatures over the warmer ocean can create massive walls of fog at Brenton's Reef, hiding the danger from passing vessels until it is too late.

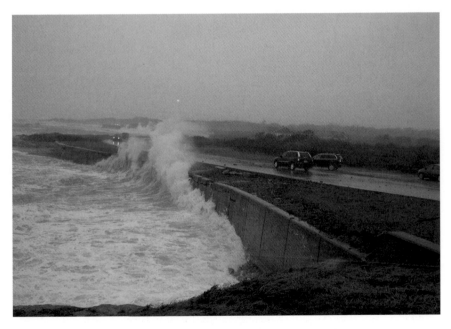

During a typical autumn storm, waves crash into the sea wall at Brenton's Point. Salt water, seaweed and sometimes rocks rain down onto Ocean Drive as cars pass, dwarfed by the sea.

of fire as Shee satt in her Rome," and Rebecca was laid to rest in a grave on the family property.

There, perhaps, her story would have ended, but for the superstitious beliefs of the time. What would follow is perhaps the most bizarre trial in American history. During the trial, evidence was brought to light that showed that Rebecca was murdered. Her son, Thomas Cornell, found himself charged with murdering his own mother. In fact, it is the most carefully documented case of matricide anywhere in colonial America.

Thomas and his wife were charged with neglecting and abusing the old woman, cheating her, withholding rent from her, starving her and depriving her of blankets for her bed in the winter. As the investigation became more involved, Thomas's wife even hinted that witchcraft had been involved in Rebecca's death.

The prosecution relied even more heavily on the supernatural to make a case against Thomas Cornell. On February 12, four days after Rebecca's passing, her brother John Brigs was sleeping fitfully. As he lay, "betweene Sleepeing and Wakeing," he felt something violently tug twice at his bedclothes. He awoke fully to find a light in the room, "like to the Dawning of ye Day," and the form of a woman, "very much burnt about the shoulders, fface and Head," standing beside his bed.

He cried out in terror, "In the name of God, what art thou?" to which the apparition replied, "I am your sister Cornell. See how I was Burnt with ffire. See how I was Burnt with ffire." Brigs took this as a message from his sister from beyond the grave. To him, the message was clear—her death had been no accident. On February 20, he gave a sworn statement describing his sister's cryptic message.

His statement reopened the investigation into the death of Rebecca Cornell and began the trial of her son, Thomas. Witness after witness came forward to talk about the suffering Rebecca faced from her son and his wife. Rebecca had complained to friends, neighbors and family that her son neglected her. She had claimed that one day, while out gathering firewood in the snow, she slipped and fell. She said that though the whole family had seen the incident, nobody came to assist her.

She had ongoing disputes with her son regarding rent. He and his family had come to live with her under an agreement to pay "Six pound a yeare, & Diet for A maide servant." He refused to pay rent or hire a maid unless she forgave him of a hundred pounds in debt that he owed to her. She refused to forgive any more of his debts; he refused to pay rent or hire a maid.

Consequently, Rebecca was forced to do many of the chores around the house. She complained of being left with no help to tend to the pigs, the

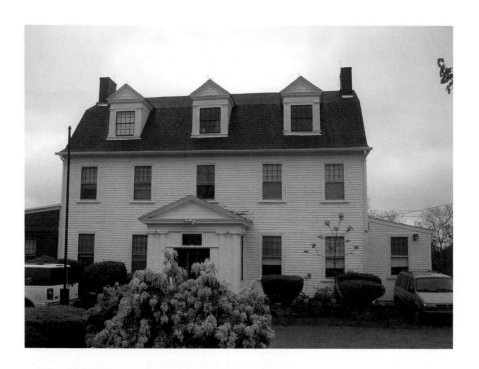

Above: Rebecca Cornell's house burned down. Her descendants rebuilt the house to nearly the same specifications. Today, it is the Valley Inn restaurant in Portsmouth.

Left: Inside the home is this replica of the fireplace that Rebecca was sitting in front of when she died.

garden and the cleaning of the house. She told some that she was forced to sleep with no blankets through the winter; that she was not able to eat with the family regularly, that she was so mistreated that she often thought of suicide but had decided to "resist ye Devil." She had, in fact, made up her mind to move in with another of her sons in the spring, leaving Thomas without a livelihood or a home. She told friends that she would move, "if shee was not otherwise disposed of, or made away," alluding to her fears that Thomas and his wife might murder her.

Other witnesses were called in to testify to the condition of Rebecca's corpse. Among the details noted by the court was the fact that part of her clothing that lay in the fire when the body was found was not burning. Parts of the curtains and valence of the bed showed signs of fire damage but were not burning when the body was found. The body was found on her left side, facing toward the west with the feet pointing north, with her back toward the bed. Of the burned portions of her clothing, it was noted that the wool had burned completely while the cotton remained whole—exactly the opposite of what one would expect. Finally, her body was laid out on the Sabbath awaiting burial and on Monday morning, fresh blood was found around the nose. These were taken as supernatural signs that Rebecca's corpse was trying to testify against her son.

Also on February 20, twenty-four men returned to the grave of Rebecca Cornell. Rebecca's body was exhumed for a more thorough examination. Upon closer inspection, a suspicious wound was found in Rebecca's stomach. What had been an "Unhappie Accident" now became a murder investigation. Evidence of Thomas and Sarah Cornell's mistreatment of Rebecca and their callous attitude about her death was presented at the trial. Sarah is said to have remarked that Rebecca's death was "a wonderfull thing," and Thomas was quoted saying that his mother "in her life time had A desire to have A good fire, and God had answered her ends, for now shee had it."

In the end, witness after witness testified that Rebecca Cornell had spoken of mistreatment at the hands of her son and his wife, but none had seen this firsthand; all character testimony presented would today be considered hearsay. While there is extensive evidence that Thomas Cornell was a poor son who did not have a good relationship with his mother, there is no physical evidence linking him to her death. In fact, there is no conclusive evidence that Rebecca Cornell's death was anything but an "Unhappie Accident." There were no witnesses to a crime; there were no bloodstained clothes; there was no murder weapon presented. The true damning evidence against Thomas came from testimony by Rebecca's ghost and her corpse. Her spectral visit to John Briggs and the various signs

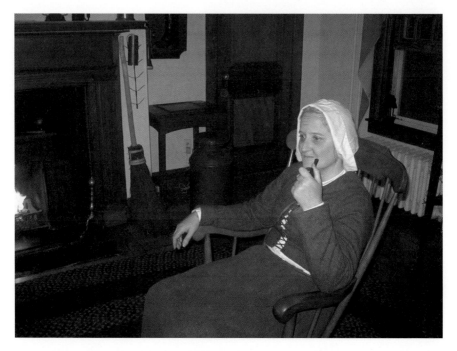

Actress Michelle Donovan portrays Rebecca Cornell for the television program *Secrets of Haunted New England*, which aired originally on the Travel Channel and appears in reruns each Halloween.

her corpse gave were taken as testimony against Thomas—testimony that resulted in his conviction for murder.

Thomas Cornell chose not to appeal the conviction. On May 23, 1673, a crowd of over a thousand people gathered to witness the execution of Thomas Cornell. Thomas's final request was that he be buried next to his mother. This request was denied, however the court did allow him to be buried on the family property, although at the point farthest away from his mother. One year later, a Narragansett named Wickopash, who had been a servant in the Cornell household at the time, was tried as an accomplice in the murder. A jury of nine Englishmen and three Narragansetts acquitted him. In 1675, one of Rebecca's other children accused Thomas's wife Sarah of being involved, but there was not enough evidence to warrant a trial.

Sarah pronounced her own judgment in the case. Shortly after the execution of her husband, she gave birth to his daughter, whom she named Innocent Cornell. On July 19, 1860, Innocent Cornell's great-great-great-great-granddaughter was born. Her name was Lizzie Borden, who was famously accused of murdering her father and stepmother in Fall River, Massachusetts, in August 1892.

Prudence, Patience, Hope and Despair

Thomas Cornell and Lizzie Borden remain linked in blood, both as relatives and accused murderers. The bizarre nature and perpetual mystery surrounding both cases can become obsessions to those who try to investigate them. The court records for both trials are carefully preserved. Gruesome physical evidence of the Borden murders remains on display at the Fall River Historical Society. While the original home of Rebecca Cornell was destroyed by fire in 1889, the Borden home at 92 Second Street in Fall River is now the popular Lizzie Borden Bed & Breakfast, and conducts tours daily.

The Cornell Homestead was destroyed by fire on December 21, 1889. Reverend John Cornell rebuilt the home using the original design in 1895. It remained within the Cornell family until 1957. That year, the property was purchased by Mario Occhi, who converted it to a popular restaurant called the Valley Inn. Fifty years later, you can still dine at the Valley Inn, a historic replica of the home where Rebecca Cornell was "killed strangely."

Two

Last in Peace

GRAVE RESURRECTION

If your great umbrage would care to meet my high dudgeon at twelve paces, I would be happy to entertain you at dawn.
—*Benedict Arnold*

Today, the name Benedict Arnold is synonymous with treason. As one of the most infamous traitors in our nation's history, Benedict Arnold forever changed the stature of his family in Newport. Once powerful and respected, Arnold's treachery helped bring about financial ruin for his family. He was forced to leave America to live in shame in England. Hated here for his crimes, he was also despised as untrustworthy in England, a social outcast. He died in London in 1801.

The Crown had been kind to the Arnold family in Newport. Benedict's great-grandfather, Benedict Arnold Sr., had been the first governor of the colony of Rhode Island. The Arnolds were successful merchants and politicians. As merchants, their chief trading partner would have been England. They had every reason to support the Loyalist movement, which was quite strong in Newport, yet Benedict Arnold chose to fight against the British. He volunteered for the American army and quickly worked his way up the command ranks. He was twice wounded in battle and had a large degree of success. He felt, however, that the Revolutionary government and military leaders did not appreciate his skills. An avid gambler, he quickly ran into debts.

Disillusioned by what he perceived as ill treatment by the Continental Congress and running short on money, he accepted a deal to surrender West Point to British forces for 20,000 pounds. When a Loyalist spy carrying proof of Arnold's treachery was captured, Arnold joined British forces fighting in America. He was paid 6,000 pounds for his efforts and saw limited action,

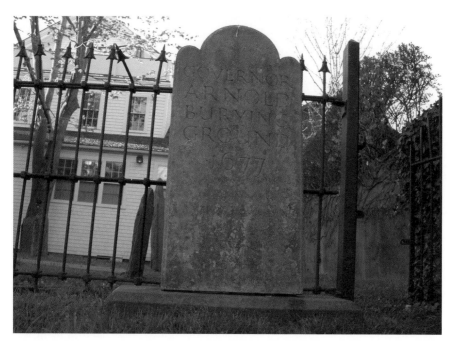

Marking the entrance to the Governor Arnold Burying Ground.

Beneath this stone is the final resting place of Rhode Island's first colonial governor, Benedict Arnold, who took office in 1663.

since the British did not trust him. He once asked a captured American officer what the Americans planned to do to him should they capture him. The officer replied, "Cut off your right leg, bury it with full military honors, then hang the rest of you."

More than two hundred years later he has not been forgiven. He is still America's most famous traitor. A descendant from a powerful family, Arnold died in poverty and obscurity. The family held large amounts of land in Newport, around what is today Touro Park.

It was near here that the Arnold Family Burying Ground was laid out. By the time traitor Benedict Arnold's father moved to Connecticut, the Arnold land in Newport was mostly sold off. Benedict's father lost most of his inheritance and became an alcoholic. Though still making a comfortable living as a merchant, Benedict Arnold's family had lost much of its wealth and power. Had he not committed such a brazen act of treachery, Benedict Arnold could perhaps have restored both to his family.

Instead, his family sank to such low status that the Arnold Family Burying Ground was nearly destroyed. By the 1950s, houses had been built in the cemetery. The graves themselves were used to dump ashes and trash. The property was being auctioned off for destruction just as heiress-philanthropist Alice Brayton happened to pass the site. She placed the winning bid for the property, tore down some of the houses that were built over the burying ground and carefully restored and documented it.

Today, it is a reminder of a family reputation destroyed and restored by the fickle winds of fortune. It can be found just off of Spring Street. If you walk up the hill from Spring Street on Pelham Street, you'll find the Governor Arnold Burying Ground set back on your left, surrounded by houses.

PALATINE LIGHT

One must never set up a murder. They must happen unexpectedly, as in life.
—*Alfred Hitchcock*

The British vessel *Princess Augusta* ran aground on the coast of Block Island on December 27, 1738. She was carrying immigrants from Palatinate in present-day Germany. These immigrants have given their name to the legend of the wreck, more commonly known as the *Palatine*. Little evidence remains of the *Palatine* beyond her legend, the deposition of her crew and a mass grave on Block Island.

No definitive remains of the *Palatine* have ever been located and there is a great deal of disagreement as to what became of her. Islanders claim

The Governor Arnold Burying Ground is tucked among historic Newport homes.

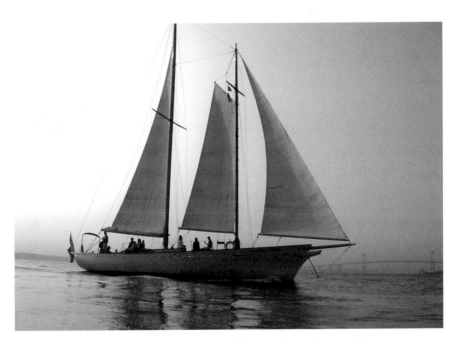

The *Princess Augusta* would have been a large sailing vessel carrying over 300 passengers at the start of its voyage. Between 100 and 150 passengers are believed to have died at sea, before reaching Block Island.

that the vessel was grounded on Sandy Point. The crew abandoned ship, leaving the passengers' fate in the hands of the storm. Before leaving, they stole everything they could from the doomed immigrants. They had been mistreated by the crew during the voyage and in the end, they were left by the crew to die.

When the tide came in, the vessel floated and was towed into Breach Cove by Block Islanders. Survivors came ashore, except for one woman who refused to leave. According to the story as it's told on Block Island, many of those on board were sickened by the harsh journey, died and were properly buried on the southwest side of the island. A marker was erected on that spot in the twentieth century that reads, "*Palatine* graves—1738."

The account, which is believed by many to be the official deposition of the crew, tells a somewhat different tale. The *Princess Augusta* was active in transporting immigrants from Palatinate to the colonies. Her arrival in Philadelphia on an earlier voyage is recorded on September 16, 1736, with 112 men and their families, totaling 330 passengers. By her fateful voyage of 1738, she had taken on a new master and crew.

Her final voyage was a harrowing ordeal for all. By the time the vessel reached Block Island, more than half the crew had died, including the captain. Winter storms in the North Atlantic brutalized the vessel, killing many with a combination of bitter cold and violent seas. There was a shortage of provisions, leading to starvation. The water supply was contaminated, causing widespread disease and death. With meager rations and a scant crew weakened by disease and cold, First Mate Andrew Brook took command of the vessel.

Pushed off course by the storms she'd encountered, the *Palatine* ran aground on Block Island at Sandy Point. In his efforts to save the vessel, Brook initially refused to let any of the passengers leave the doomed vessel. Finally, at the urging of the people of Block Island, the call to abandon ship went out. The crew claims that they managed to save all passengers left aboard at the time of the sinking. They testified that Brook ordered them to save as much of the cargo as they could, both before and after she broke up on in the pounding surf.

There is another version of the tale of the *Palatine*, one that is well known throughout Rhode Island. This version leaves only one survivor aboard the doomed vessel. Her journey across the stormy North Atlantic in winter would have been difficult under the best of circumstances. With insufficient provisions and a green crew, the voyage was certain to be disastrous. Limping toward the end of her voyage, the crew spotted the Montauk Light through the storm. They set a course that would take them to shelter and end their journey. Suddenly, there was an awful crash. The vessel quivered

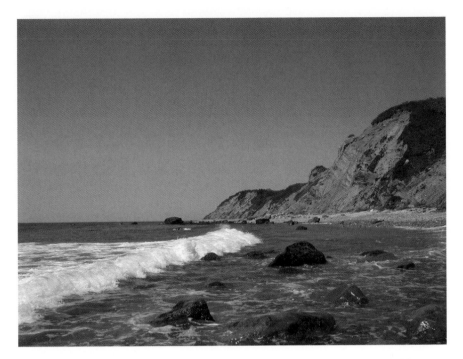

The Mohegan Bluffs rise on the eastern shore of Block Island. It is here that the *Princess Augusta* may have met its fate.

as it ground to an abrupt halt, fatally broken upon the rocks. Too late, the victims found that they had seen a decoy lighthouse set up on Block Island to lure the *Palatine* to her death.

Wreckers descended upon the ship like bloodthirsty vultures, as she lay crippled and helpless. Their sole objective was to strip the *Palatine* of anything valuable. They brutally murdered everyone aboard who did not join their dastardly crew. They had to eliminate all evidence of their crime or face prosecution as pirates. Once the ship had been plundered, it was set ablaze just as the tide freed it from the rocks. As the *Palatine* burned and sank, one woman appeared on her deck, screaming in terror. As the Block Islanders looked on, the woman perished horribly aboard the *Palatine*.

Whatever the true story of the *Princess Augusta*, her tale has been immortalized. At least one survivor was known to have lived on Block Island. Her story implicated both crew and islander alike in the plunder of the vessel. Block Islanders, for their part, dismiss her as a witch whose stories were fabrications made by the devil. From these events, we have the fabled *Palatine* Light.

The legend of the *Palatine* Lights has been around since the sinking of the *Princess Augusta*. In the legend, a sailing vessel from days of old appears

on the horizon. As it sails close, it bursts into flames. One woman appears on its deck, screaming in terror as the vessel disappears beneath the waves. A sighting of the *Palatine* Lights is considered a bad omen—generally a sign of an impending storm.

Benjamin Congdon, born around 1788, wrote of the *Palatine* Lights, "About the burning *Palatine* ship…I may say that I have seen her eight or ten times or more…Nobody doubted her being sent by an Almighty Power to punish those wicked men who murdered her passengers and crew." Sightings have continued to the present day. Though countless sightings were reported through the eighteenth and nineteenth centuries, the frequency of sightings in modern centuries has dropped substantially. There was a mass sighting of "a large, glowing fireball," off the coast in 1969, which was never explained.

Legend has it that the *Palatine* will continue to reappear, searching for any descendant of the Block Island pirates. In 1867, John Greenleaf Whittier immortalized the *Palatine* legend in his poem "The *Palatine*." He writes of the incident:

> *Down swooped the wreckers, like birds of prey,*
> *Tearing the heart of the ship away,*
> *And the dead had never a word to say*

> *And then, with ghastly shimmer and shine*
> *Over the rocks and the seething brine,*
> *They burned the wreck of the Palatine.*

Later in his poem he presents a warning regarding the return of the legendary ghost ship:

> *Behold! Again, with shimmer and shine*
> *Over the rocks and the seething brine,*
> *The flaming wreck of the Palatine!*

> *And the wise Sound skippers, though skies be fine,*
> *Reef their sails when they see the sign*
> *Of the blazing wreck of the Palatine!*

The people of Block Island deny this version of the story. Some evidence seems to suggest otherwise, however. If you go to Block Island, you'll find a pleasant area around the Old Harbor. The local businesses rely on tourism and are generally friendly to visitors from the mainland. Should you venture off the beaten path for any length of time, Islanders will confront you and

curtly remind you that "there is nothing to see here." The quaint old New England need for privacy is strong in the island folk. Could this dislike of visitors once have exhibited itself through acts of piracy, such as the wreck of the *Palatine*?

Strong evidence suggests that the wreckers of Block Island were real and that they did set up a fake lighthouse at times to lure vessels to their doom. There were tremendous health problems on the island due to inbreeding among the population. Eking out a meager existence through farming and crime was not attractive to most women. With few wives to choose from, a certain amount of in breeding took place on the island. This led to a higher rate of mental illness on the island. There also is a traditional link to piracy, as Rhode Island had exceedingly lenient laws regarding piracy.

Perhaps most curious of all is the placement of the mass grave of the shipwreck victims. The Indian Cemetery is situated not far from the southeast corner of the island. Also in the southeast corner of the island is the mass grave of the *Palatine* victims. Whereas the Indian Cemetery is prominently placed on a hill, accessible to people, the *Palatine* graves are located deep in one of the most remote areas of the island. Set back, virtually inaccessible because of dense overgrowth of thorns and brush, stands the modest memorial marker. It is, oddly enough, hidden among the swamps on that section of the island.

It is as though the islanders wished to hide the bodies. Islanders claim that they assisted in the repair of the ship and it left the island, though it was never seen again. Perhaps most damning of all is the reappearance of the ghost ship, ablaze on the horizon, bearing shame to all those involved in her destruction.

WHITE HORSE TAVERN

Drink to me!
—*Pablo Picasso*

The White Horse Tavern has the distinction of being the oldest tavern in the United States. It was built as a home for Francis Brinley and his family in 1652. In 1673, William Mayes purchased the property and converted it into a tavern. It quickly became a popular meeting place in Newport. After all, alcohol was the drink of choice in colonial Newport.

Early settlers were extremely distrustful of water as a beverage. Water could become tainted, leading to illness and death. Alcohol was much easier to store in wooden barrels for extended periods of time. The *Arabella* sailed

Block Island's Indian Cemetery is easily accessible, as would be expected. The *Palatine* graves are located deep in undergrowth in the swamps of the southeastern side of the island, as though the mass graveyard was intentionally hidden.

The White Horse Tavern has been serving spirits since 1673.

to the New World in 1630 with three times as much beer as water, as well as ten thousand gallons of wine. Additionally, each person would have carried a personal ration of hard spirits.

Beer brewing in America was experimental. Connecticut Governor John Winthrop brewed his beer from corn, Ben Franklin brewed spruce beer and George Washington drank molasses-based brew. Newport became a center of rum production as a result of the Triangular Trade and the poor quality of the local beer. Beginning at an early age, it was common to drink alcohol every day, starting at breakfast.

Public duty moved to the public houses. Colonists expected to be rewarded for public service. Generally a man got a large beer for taking the time to vote. Elected officials and judges drank all the way through all government functions. To make it easier, government functions were held at the White Horse Tavern in Newport. The colonial government of the colony of Rhode Island and of its capital, Newport, met and drank here.

This made it a very influential location. When William Mayes Jr. took over the important family business, there was an outcry from the British Empire. Willie Mayes had been a successful pirate. When he returned to Newport with his booty, the British hoped that his property would be confiscated and he would be hanged. Instead, he was welcomed by the people and granted a license to sell "all sorts of strong drink."

As Newport's fortunes changed, so did the White Horse Tavern. During the Revolution, British forces occupied the building and the family abandoned it during the war rather than assist the enemy. The tavern fell into disrepair and was eventually rescued by the Preservation Society. It has since been sold and reopened as a tavern and fine-dining restaurant— with plenty of ghosts.

Over the years there have been numerous sightings of a man dressed in shabby, old-fashioned clothes. Most often he is spotted near a fireplace in one of the dining rooms, but was once spotted in an upstairs men's room. In one incident, two employees had locked up for the evening when they heard an intruder walking around. They searched for the source of the footsteps, but could find nobody else in the restaurant. There is a famous photograph, taken for publicity, of a table setting that has the mysterious image of half of a woman's face hovering over the table.

The tavern's owners came across a newspaper clipping from the 1700s of a man who died in his sleep seated next to the fireplace. Fearing smallpox or another disease, he was quickly buried in the Common Burying Ground in an unmarked grave. Nobody ever discovered his identity. Perhaps he is the spirit near the fireplace in America's oldest operating tavern.

The Peleg Sanford House houses apartments and shops. Portions of this building date to the 1640s.

PELEG SANFORD HOUSE

Behold also the ships, which though they be so great, and are driven of fierce winds, yet are they turned about with a very small helm, whithersoever the governor listeth.
—James 3:4

Peleg Sanford served as a colonial governor of Rhode Island from 1680 to 1683. At what is today 4 Broadway, he built his homestead. It is believed that he built the home sometime in the 1640s. As the nature of Broadway changed from residential to commercial, so did the Peleg Sanford House. In 1827, the building was enlarged to include a storefront. In 1845, it was enlarged again. The building is popularly known as "Lalli's," after the Lalli family. Joseph Lalli operated a variety store and newsstand in the building from 1923 to 1986.

The additions were made around the existing structure of the Peleg Sanford House. The original house still stands, safely encased within the additions of the nineteenth century. Protected from the environment, the central part of the building may be one of the oldest structures in Newport.

Today, there are ground-floor shops and upper-floor apartments. One thing that the apartments have in common is the presence of at least one ghost. Little is known about him. Apparently a man of few words, he has so far chosen to communicate indirectly. In keeping with Newport tradition, he makes his appearance whenever anybody in the building throws a party. It was at one such party that a guest noticed the shadowy figure of a man petting the cat in the kitchen. As it dawned on her that everybody was supposedly in the living room, she looked back at the kitchen to find the figure gone without a trace. She had the intuition that his name is Thomas, the name residents of the Peleg Sanford House still use when speaking of him.

Thomas is apparently particularly fond of animals. Cats that live in the apartments exhibit bizarre behavior. One cat often swirls about the floor in a tight figure-eight pattern, as though rubbing itself against someone's legs. Another feline resident seems less fond of Thomas, however. This cat is somewhat unfriendly in general. This cat has been known to hide under furniture to ambush the ankles of unsuspecting guests. Since moving to her current address, she's been spotted many times attacking thin air from underneath the furniture. She seems surprised when her attacks fail to draw any blood. She can also be found growling, hissing and arching her back at nothing in particular—at least nothing that most humans can see.

Thomas has been known to play with any electronics that he can find. He'll turn items on or off or otherwise manipulate devices. One resident was particularly disturbed when Thomas opened a bathroom window. "I live alone," he explained, "I would have been okay if the window had gone down. I'd be fine with that. Gravity could do that. The bathroom window was lifted up one night while I was sleeping!"

Those living in the Peleg Sanford House have the privilege of living in one of the oldest buildings still standing in Newport. They also share in the honor of living with a mysterious roommate from a bygone era. Whoever Thomas is or was, he has chosen not to leave his historic dwelling. Occasionally, he even enjoys a cool breeze on a warm summer night.

ELKS LODGE

> *Experience is the best teacher, but a fool will learn from no other.*
> *—Benjamin Franklin*

During the Civil War, the Naval Academy had to be relocated from Annapolis. Accordingly, the navy leased the Atlantic House Hotel at the corner of Bellevue Avenue and Pelham Street, and throughout the war, this

The Elk's Lodge is on the site of the Atlantic House Hotel, which was used by the Naval Academy during the Civil War.

was the location for the U.S. Naval Academy. The Atlantic House Hotel had been built in 1844. The Naval Academy was founded at Annapolis in 1845 by the secretary of the navy, George Bancroft. Bancroft was a lifelong summer resident of Newport, so Newport was his natural choice for the Naval Academy to convene during the war.

A few years after the war, a fire destroyed the Atlantic House. On that spot today is the Newport Elks Lodge. A beautiful, historic building, the Elks Lodge has ghosts wandering around. Perhaps some of them were among the graduates there who died during the Civil War. Possibly, they were guests of the Atlantic House.

The most notable paranormal event that has been recorded at the Elks Lodge involves a painting at the top of the staircase. It is the portrait of a woman and a child. When the image of the child is blurred, it's a sure bet that his ghost is wandering about. The child's ghost has been spotted many times on the second floor.

Other phenomena include the lights turning on and off by themselves. These don't seem to be simple power fluctuations or blackouts; people claim that the switches themselves flip up and down. Also, there are reports of unexplained footsteps heard throughout the lodge.

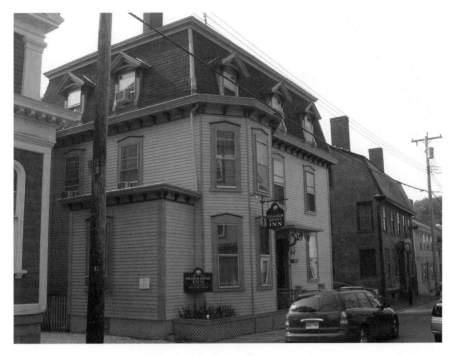

The Pilgrim House Inn on Spring Street dates to 1775.

PILGRIM HOUSE INN

This life at best is but an inn, and we the passengers.
—James Howell

Newport reached its peak just prior to the American Revolution. During this time, many colonial homes were built. Throughout the difficult years of the war, there was a great deal of destruction. It is estimated that as many as eight hundred homes were destroyed during the war. British troops occupying Newport destroyed many homes for use as firewood.

Many of the homes spared were the newer homes at the time the war started, which explains why so many of today's historic Newport homes were built around 1775. One of these homes is the Pilgrim House Inn, a featured stop on Newport's Ole Town Ghost Walk.

Today the Pilgrim House Inn serves as a charming bed-and-breakfast, with quaint, colonial charm, a friendly staff—and a ghost. There is a large deck on the rear of the building that overlooks Newport Harbor, with some of the most breathtaking views on the island. The deck is on the third floor. The inn sits high on the hill overlooking the City by the Sea. A delightful

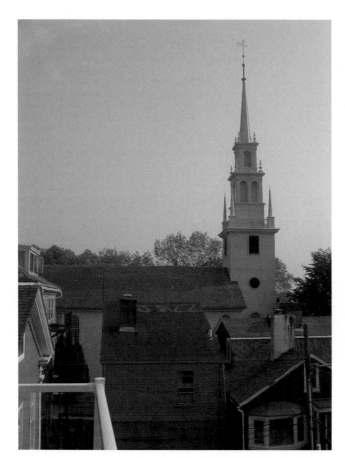

Panoramic views from the rear of the Pilgrim House Inn take in all of Newport Harbor. The view toward Trinity Church shows the colonial charm that has made Newport a vacation destination.

koi pond with a fountain is the centerpiece for a picturesque back yard. The modern amenities have been pleasantly blended with the historical feel of the inn. In the evenings between April and October, a tour group will gather quietly outside the Pilgrim House Inn to share ghost stories.

Guides tell that the ghost of a little girl resides within the Pilgrim House Inn. A housekeeper here had the intuition in the presence of the spirit that her name is Jessica, so that's what she is called today. Little is known about Jessica. The building has served as an inn, a shelter for homeless men and a private residence. In the 1800s, the Currens family lived here and wrote a letter back home to Ireland in which they spoke of a son named James, a daughter named Margaret and a baby girl whose name is not mentioned. Perhaps this baby girl is Jessica.

Like any living child, Jessica can be very mischievous. One of her most famous practical jokes came one evening as a housekeeper and her daughter were doing laundry. Jessica slammed the dryer door practically on their

hands and then started the dryer. It's not a dryer that starts automatically when you close the door; you have to physically press a button.

She loves to ring the intercom buzzer in empty rooms. You can imagine that if you're working in the inn on a dark and stormy night and the empty rooms start buzzing with activity, it can be very unnerving. For reasons that we don't understand, Jessica prefers rooms 8 and 11. In those rooms, guests report seeing unexplained shadowy movements and hearing the laughter of a little child. One guest in room 8 left the following message in the journal provided by the inn for guests, "I don't know if you'll believe me, but this room is haunted. Perhaps she is looking for someone she knows."

One tour group is reported to have spotted the ghost of Jessica standing in the doorway on a hot summer night. A little girl in an old-fashioned gray dress appeared at the bottom of the stairs and then vanished. A quick check with hotel staff confirmed that there were no children staying at the inn that evening. On another tour, a young couple announced that they had stayed the previous night and had heard "what sounded like a music box coming from the next room." The next morning, they inquired about the guests in the next room only to find that the room had been vacant the night before. Once they learned about the ghost of Jessica, they were convinced she had been playing in the next room that night.

If you visit Newport and are looking for great accommodations, the Pilgrim House Inn is a wonderful choice. It has a great Victorian charm, a friendly staff and spellbinding views. Just be sure to exercise caution. There are children at play here.

Three

Great Gilded Ghosts

Astor's Beechwood

I'd like to live as a poor man with lots of money.
—Pablo Picasso

Beechwood was built in 1851 for a merchant named Daniel Parrish. It was purchased in 1881 by William Blackhouse Astor, grandson of John Jacob Astor. As recently as 1999, the senior Astor was listed as the fourth-wealthiest American ever to live, beating out Microsoft's Bill Gates. William married Caroline Schermerhorn in 1853. She insisted on being called "The Mrs. Astor" by her friends. She used her wealth to become the undisputed "Queen of American Society." When she began to summer at Beechwood, it became a focal point for society.

The Astors hired Richard Morris Hunt to renovate Beechwood for them. The renovations totaled over $2 million in 1881. With society swarming over the cottage for eight weeks each year, it was vital that it be impressive to even the wealthiest visitor. The high point of Newport summer society was Mrs. Astor's Summer Ball.

Mrs. Astor finally retired from the social scene in 1906 and died in 1908. Her son, John Jacob Astor IV, divorced his wife after the passing of his mother. In 1911, he married a much younger woman, Madeleine Talmadge Force. The ceremony took place in the ballroom at Beechwood. Immediately following the wedding, the couple took a lengthy vacation in Europe. There was a great deal of gossip surrounding their marriage; going to Europe spared them from dealing with it. They expected the scandal to be forgotten by the time they returned in April 1912.

The return passage was booked for the maiden voyage of the new luxury liner *Titanic*. It's a honeymoon from which John Jacob Astor IV would never return. His pregnant bride survived, but J.J. Astor did not. When his body

Great Gilded Ghosts

The Astor's Beechwood Mansion is a living history museum filled with professional actors in costume.

was recovered on April 22, evidence suggests that he had been killed by the falling smokestack as he and others were trying to free one of the collapsible lifeboats.

Today, his home in Newport is a living history museum. Actors portray the Astor family, as well as friends and servants, at the height of the Victorian era. From the moment visitors enter, performers make them feel as though they are wealthy members of the so-called "400," a listing of the wealthiest Americans. Other experiences include murder mysteries and tours of the jazz age of the 1920s.

While you're there, try to find some of the ghosts that are said to haunt the cottage. It was once featured on an episode of *Ghost Hunters*. Perhaps you can be the one to unlock the identities of the spirits that roam the cottage.

There have been instances of candles blowing out by themselves and footsteps on a secret staircase. People have heard the spirits in the dead of night. Guests and performers alike have often reported feeling unexplained cold spots and having a sense of being watched. The one guarantee is that these remarkable performers will give you the sense that you are visiting with the ghosts of the Astor family, friends and servants as they immerse you in a gilded moment in history.

GHOSTS OFF BROADWAY

All the world's a stage,
And all the men and women merely players
—William Shakespeare, As You Like It

On Ayrault Street, off Broadway in Newport, you'll find a row of spectacular Victorian homes. Until a few years ago, one of these served as a boarding house. The Jean Hunt House was built around 1872. Under its previous owners, it was a pleasantly haunted boarding house for a group of actors in Newport. Benign ghosts wandered about, sharing a happy home with the theatre folk of the area.

There are several theatres in Newport, and the theatre community is relatively tight-knit. The boarding house on Ayrault Street housed actors who worked at a variety of theatres throughout the region. Most of the actors, at one time or another, worked for the Newport Repertory Theatre, as well as for other theatres. An exciting bunch of young men and women, they seemed to keep their ghosts happy.

The ghosts manifested themselves in many ways. One actress reported feeling a gentle pressure on her chest each night as she went to bed, as though a cat was climbing onto her chest to sleep each night. One morning, after she had overslept for an important appointment, she was awakened by the blankets flying off of her bed. She found them neatly spread out on the floor of the room, "without so much as a wrinkle in them."

Others have reported hearing the soft voice of a young girl in the house on the upper floors and the voice of an old man on the lower floors. The girl seemed to inhabit the area around a small boarded-up door on the top floor. Both spirits were friendly and had good relationships with the home's living occupants until the house changed owners.

The new owners bought the property with the intention of making extensive renovations to the structure. Accordingly, the boarding house was closed and all residents were given eviction notices. They were given time to find new homes before construction was set to begin. Once the notices were served, however, it became apparent that the spirits of the home were going to miss their living friends.

Residents noticed a banging noise emanating from the pipes on the first floor. It began the day eviction notices were served and continued until everyone had moved out of the home. "There was a definite increase in the amount of unexplained activity," recalled one of the actors. "It was as if the ghosts did not want us to leave." The worst, it seems, would happen during construction.

Great Gilded Ghosts

The Jean Hunt House, circa 1872, was the site of many paranormal events.

One actor returned a few months later to pick up any mail that might have been delivered to his old address. "As soon as I got there," he says, "the new owners began questioning me about ghosts in the building." They had seen more than their share of ghostly activity during construction.

The first problems arose after they pried open the small door on the upper floor. It revealed a small room that was once used as a closet. The floor had become unsafe, which is why the door had been boarded up. Inside the closet, workers discovered a very old dress in a corner. The dress was musty and tattered with age and had a dark stain on the chest. The dress was disposed of in a dumpster.

Immediately, a bizarre series of accidents began. Tools and supplies toppled without warning, nearly injuring several workers. A hammer mysteriously toppled from scaffolding and severely injured one of the workmen. The crew left the job and refused to return to the job site. Construction work sat incomplete for weeks, awaiting a new construction crew.

The owners of the Jean Hunt House became desperate. They hired a psychic from New York to help. She arrived in Newport and attempted to enter the house. Suddenly, she stopped on the porch. She claimed that the spirit of an "old, angry man" did not want her to enter his house.

During this time, a series of heavy rainstorms hit the area. The basement flooded as water poured in through the incomplete construction. The crew brought in to clean up the water discovered something even more bizarre.

In the basement, the water damage brought down a wall that concealed a secret room. Long forgotten, the small room contained "animal bones arranged carefully on the floor in a pentagram." To everyone's surprise, a simple cleanup of water damage became a spiritual cleanup.

The house has been repaired. Construction was eventually completed. The actors have all found places to live. We may never know what spirits resided in the boarding house at Ayrault Street, nor their motivations. We may never know the mysteries behind the bloody dress and the secret room filled with animal bones. However, there have been no new ghost sightings since the secret room was destroyed.

FIREHOUSE THEATER

Music should strike fire from the heart of man, and bring tears from the eyes of woman.
—Ludwig van Beethoven

Newport's Firehouse Theater is a delightful forty-nine-seat theater that occupies a former fire station. The combination seems to be attractive to spirits, as today several ghosts haunt the building. The Firehouse Theater provides an intimate stage for area actors. Some of the region's brightest award-winning performers are likely to set foot on the stage. Its shows regularly garner excellent reviews in the media and it has earned a well-respected status within Rhode Island's art community.

The building was originally built in 1885 as Steam Fire Engine Station 4, serving Newport's Second Ward. Hope 4, one of Newport's oldest fire companies, originally occupied the station. Hope 4 was established prior to 1790 as a private firefighting club. By the time Steam Fire Engine Station 4 was built, Newport had a full-time paid fire department.

Understandably, Newport is very nervous about fire. Old wooden buildings that are often in direct contact with each other in long rows make firefighting particularly important. A steady sea breeze may cool the citizens in the summer, but it can also serve to fan and push flames in a disaster. Newport's location on an island gives it lower water pressure than many other communities, potentially hampering firefighters.

In 2007, Newport suffered a major historic loss when the House of Scrimshaw was destroyed by fire. Five fire departments, with over two hundred firefighters, were called to battle the blaze. For the first time in nearly a decade, a general alarm was called at roughly 2:30 a.m. The alarm at the Newport Fire Department Headquarters began sounding out a code to any firemen in Newport, calling them to duty and giving the location of the blaze. This way, they could report directly to the fire.

The Firehouse Theater is located in a firehouse built in 1885.

When the fire reached the flashover point, the gasses in the superheated building exploded through the windows. Flames shot out of the windows like jet engines and hot wind blasted a crowd of onlookers in the Brick Market. Suddenly, a race was on to save the historic district. Water sprayed on the roof of the nearby art gallery immediately turned to steam in the intense heat. The clothing store that shares a wall with the House of Scrimshaw suffered extensive damage. Worst of all, the building was declared a total loss, so heavily damaged that it had to be torn down that day to prevent injuries in the busy downtown area.

The cause of the fire was deemed arson. In fact, a serial arsonist was terrorizing the city. As of this writing, the arsonist is still at large. Fortunately, there have been no serious injuries in a half-dozen confirmed attacks in 2007. There are also similarities to a slew of arsons from a decade ago, leading officials to surmise that this might be the same arsonist.

Newport remains on edge. Civilian arson-watch groups patrol the city, hoping to prevent any more historic losses. People are nervous, calling the fire department at the first sign of smoke, often the result of woodstoves and fireplaces. In a city as historic and susceptible to fire as Newport, the fire department has long been an integral part of the community.

Steam Fire Engine Station 4 once protected a large area of Newport around Broadway, north of the downtown area. The building housed horses and firefighting equipment in the engine room on the ground floor, as well as the wardroom where on-duty firefighters could gather. There was even

Flames tear through the House of Scrimshaw. The historic building fell victim to an arsonist in 2007.

a room for public voting built into the station, cementing its prominence in the community.

The firefighters' dormitory occupied the second floor of the station, and there was a prominent tower on the front corner of the building. Today the tower is missing the top twenty-five feet of its original height. The station was converted into the Firehouse Theater in 2000 and has made itself an important part of Newport's art scene.

Though it is a theater, the ghosts there are believed to come from its days as a firehouse. There are some truly unusual phenomena that have been reported by a wide variety of people. It is not uncommon for the cold-water tap in the smaller restroom to turn on by itself. Witnesses claim that the water will suddenly begin to flow and then stop just as suddenly a few moments later. Some have pointed out that, to a fireman, a good flow of water is of utmost importance. Perhaps our ghost is checking to see that there will always be water should it be needed.

During rehearsals for one play, actors and crew heard a loud banging, as though someone were "banging on the heavy stone walls with a pipe." According to the play's director, Deb McGowan, "the noise continued during rehearsal and we tried to locate its source." In spite of an extensive search, nobody could find the cause of the banging, except that it seemed to be coming from inside of the stone wall at the front of the building.

The clock tower at the Tennis Hall of Fame looks across the grass courts to the dark Casino Theatre today.

Coincidentally, the play Ms. McGowan was directing was the comedy *Cemetery Club*.

The building has been a vital part of the community since 1885, first as a link in Newport's firefighting brigade and now as a popular professional theater. Its rich history and entertaining assortment of shows make it a great destination for an evening of theater in Newport. All shows are **BYOB**, though spirits may appear, if you know what to look for!

ENTERTAINING ENTITIES

I have the terrible feeling that, because I am wearing a white beard and am sitting in the back of the theatre, you expect me to tell you the truth about something. These are the cheap seats, not Mount Sinai.
—*Orson Welles*

Newport began, slowly, to emerge from its half-century of poverty between 1840 and 1850. By 1856, it was touted as "the Queen of Resorts." Several factors created this resurgence for the "City by the Sea." In 1847, the Fall River Line was founded. The Fall River Line operated steamships that sailed from New York to Newport and Fall River. Strong competition kept fares low, but the vessels were extravagant. Referred to as "floating

palaces," the interiors of these ships were ornately decorated to satisfy travelers of the gilded age.

By 1875, the Old Colony Railroad connected New York, Fall River and Boston. Connecting the cities of Boston and New York through picturesque Newport facilitated the summer stays at the cottages that sprang up on Bellevue. In the days before air conditioning, cool ocean breezes attracted the wealthy to the island. The same breezes that carried sailing vessels to Newport in her early days now carried sailing yachts of the wealthiest men in the world.

Summering in Newport became highly fashionable with the rich society. In 1853, the elite Newport Reading Room became the exclusive gentleman's club. Captain Henry Augustus "Sugar" Candy, a personal guest of Commodore James Gordon Bennett, rode his horse onto the porch of the Reading Room, upsetting the wealthy guests relaxing there. Allegedly, he did this as part of a bet with the commodore himself.

Captain Candy was permanently barred from the Reading Room for his behavior, prompting the creation of the Newport Casino. On August 30, 1879, the *Newport Mercury* reported, "James G. Bennett has bought Sidney Brook's estate on Bellevue Avenue for $60,000. It is rumored that Mr. Bennett's intention is to make this into a new clubhouse…by reason of the dismissal of a friend from the Newport Reading Room for a clear violation of the rules of that institution."

With contributions from other wealthy patrons, the Casino was built next to Travers Block. Richard Morris Hunt designed Travers Block in 1870 and the Casino was deliberately designed to be harmonious with it. A private club in its early days, the Casino was open to both men and women. The Globe Theatre Band, led by John Mullaly, performed at the Casino on what would eventually become the tennis courts. Mullaly's Orchestra, as it is popularly called, became a fixture at the Casino, though not always to great fanfare. A *Boston Herald* review in July 1888 lambasted one dance as "a flop," noting that Mullaly's Orchestra played for no more than four couples on the dance floor. The *Herald* reported the evening as so dull that "the employee in charge of the coat room read a small novel during the evening."

The U.S. National Lawn Tennis Championship (later called the U.S. Open) played its first tournament at the Casino in 1881. The courts are the oldest continuously used competition grass courts in the world, and the only competition grass courts open to the public for play today. Tennis, as well as archery, horse shows, lawn bowling, theatre, concerts and other activities, helped open the Casino to the public. On June 15, 1882, the Casino was ablaze with sunflowers in honor of Oscar Wilde, who presented a lecture

The historic grass courts were once decked out in sunflowers to honor Oscar Wilde. Wilde took the opportunity to tease Americans for their taste in clothing.

on home decoration and clothing styles. In true Wilde fashion, he chose to lampoon the popular American clothing and home decoration styles of the day, angering many of his hosts in Newport. He mentioned the Newport Casino briefly in his story "Canterville Ghost" in 1887.

By the Roaring Twenties, there was a need for a separate performing space. The Casino Theatre opened on June 6, 1927. It had five hundred removable seats and could double as a ballroom. It became a part of the "Straw Hat Circuit," a group of smaller theatres that attracted major stars of the day. Among the most notable in a long list of performers at the Casino Theatre were Helen Hayes, Basil Rathbone, Will Rogers, Orson Welles, Tallulah Bankhead, Olivia deHaviland, Vincent Price, Eva Gabor, Shelley Winters, Ethel Barrymore Colt and Gypsy Rose Lee, just to name a few.

Actors have always been notoriously superstitious. It is considered bad luck for a performer to even mention the name of Shakespeare's *Macbeth*. It must instead be referred to as "the Scottish play." It is bad luck to whistle in a theatre. It is even bad luck to say, "Good luck," to someone who is about to perform. A group predisposed to superstition is also likely to believe in and encounter ghosts.

In fact, virtually every theatre, no matter how big or small, has a ghost or two. Theatres seem to attract spirits. Perhaps it is the excitement of performance that spirits are unable to give up in death, or perhaps it is the joy of sitting in the audience. Whatever the cause, theatre ghosts can be among the most forceful. While other spirits are often content to remain calm for long periods of time, theatre spirits are often more flamboyant in behavior.

In one incident at the Casino Theatre, a local performer was on stage in a show that was not going well. He forgot his line and froze. Suddenly, he noticed a woman crouched in the wings, trying to get his attention. When he saw her, she whispered his line to him and the show continued after only a tiny pause.

When he tried to find her, he discovered that there was no access to that part of the wings that evening because of props and set pieces. Nor could he find any woman who fit the description of the woman who had bailed him out. In fact, nobody had heard of a woman matching her description. The actor feels that perhaps she was the ghost of an actress who had found herself in the same position and wanted to save him from her embarrassment. "I will never forget my muse," he says.

In another incident, a group of actors at a rehearsal were discussing ghostly activity at the theatre. One actor announced that he did not believe in ghosts. Suddenly, one of the stage lights burst into flame in a puff of smoke. Just as quickly, the flames disappeared and the light continued to function without even scorch marks around it.

There were always tales of ghosts interfering with props and technical equipment in the theatre, turning stage lights off and on or moving set pieces. Stories began as soon as the theatre opened and continued until it finally closed its doors. Currently, there are plans to possibly refurbish and reopen the Casino Theatre. A difficult battle lies ahead for supporters. Each passing year brings the theatre closer to decay, and modern fire codes and building codes make such a project incredibly expensive. It is nearly every actor's dream, however, to tread the boards at the infamous Newport Casino Theatre.

NEWPORT ART MUSEUM

Art washes away from the soul the dust of everyday life.
—Pablo Picasso

The main building of the Newport Art Museum is the Griswold House, an example of Richard Morris Hunt's Stick Style architecture. John

Great Gilded Ghosts

The Griswold House at the Newport Art Museum, designed by Richard Morris Hunt.

Noble Alsop Griswold, who resided in Newport for nearly a half century, commissioned the home in 1864. He made his fortune in the China trade and in railroads and had served as the U.S. consul in Shanghai. Griswold was an "intense Union man," and returned from abroad in 1862 to help finance volunteer troops. He leased Kingscote until his own cottage was completed.

Both Mr. and Mrs. Griswold were notorious for hosting lavish events. They were divorced in 1890. On Christmas in 1902, their only son committed suicide. John Griswold died in his home in Newport on September 13, 1909. His ex-wife died several months later. The Griswold House remained vacant for several years. It was purchased by the Newport Art Museum in 1915 and has been an art gallery since 1916.

The Griswold House was the setting for strange, unexplained events and ghost stories for decades. Staff members claim that ghostly activity seems to have died down after recent renovations, at least for now. During the renovations, one woman was left to close the Griswold House at the end of the day. All other staff and construction workers had gone home for the evening. As she was securing the first floor, she heard music and saw light coming from the second floor. She assumed that the construction crew had left a radio and some lights on, but when she reached the top of the stairs,

the music and light were gone. She continued locking up downstairs when she heard the music and saw the light once again. When she reached the top of the stairs, all was dark and quiet. As she was leaving the building, she once more heard music and saw light. This time, she simply called upstairs, "Whoever you are, I'm leaving now. Have a good night, but please don't set off any of the alarms!"

You can visit the Griswold House as well as the Cushing Gallery and the Gilbert S. Kahn Building at the Newport Art Museum. You'll find an extensive collection of regional art. The collection includes modern works as well as historic pieces. Remember, the ghostly activity can start again at any time. Maybe you will be the next to encounter one of the spirits that stroll the galleries of the Griswold House.

REDWOOD LIBRARY

A library is an arsenal of liberty.
—*Unknown*

The Redwood Library and Athenaeum is the oldest lending library in America. The library was founded in 1747 by a group of forty-six men "having nothing in view but the good of mankind." Its mission continues today, after 260 years of continuous use. Inside are more than 160,000 volumes, archives and manuscripts, as well as a collection of historic artifacts, furniture, sculptures and paintings.

The library's first major renovation came after the American Revolution. Venting their anger at the American Rebels, British troops heavily vandalized the library building and stole or destroyed more than half of its books. Today, preservation continues to be a primary concern.

The Redwood is an independent subscription library supported by membership fees, endowments and gifts. It is open to qualified scholars, researchers and those making occasional use of the collections. In the spirit of a true athenaeum, there are often performances, seminars and educational programs offered for the enjoyment and enrichment of both members and the general public.

Surrounded by historic art pieces and ancient tomes, you can't help but feel a presence in the library. In particular, the reading room has been known to leave visitors with the profound feeling that they are being watched. Part of this feeling undoubtedly comes from the massive collection of seventeenth- and eighteenth-century paintings that adorn the walls. Each figure seems to gaze directly at you wherever you go. Their austere expressions gaze upon you as if to ensure that the books and artwork will

The Redwood Library suffered greatly during the American Revolution. Today, it has recovered, and is the oldest lending library in America.

never again be ill treated as they were by occupying British forces during the Revolution.

Still, as a chill runs the length of your spine, you have to wonder, "Am I really alone here?" Spirits have a way of connecting through artwork. Some cultures have even held the belief that a person's soul can be captured in its image. It may be that more than one spirit quietly haunts the library.

PRESERVATION SOCIETY

The reason why men enter into society is the preservation of their property.
—John Locke

The Newport Preservation Society saved many of the old summer cottages on Millionaire's Row from destruction. Its main cottages today include the Elms, Mable House, Hunter House, Chateau Sur Mer, Rosecliff and the Breakers, to name a few. These elegant mansions had become cumbersome and outdated. The wealthy families that once built them were no longer interested.

Newport's largest mansion, the Breakers, can be seen from the Cliff Walk.

Other destinations became more fashionable; the cottages fell out of style as the buildings became old and obsolete. Nobody hosted huge formal dinner parties followed by ballroom dancing with a full orchestra. The stylish wealthy craved modern amenities, such as air conditioning. Styles simply changed and the young millionaires began to move to modern affairs near Hollywood.

So, for a number of reasons, Newport became unfashionable and the mansions became worthless. Often abandoned, vandalized by locals, many of these mansions became unsafe and had to be destroyed. Those that remained required so much money to refurbish them that they were worthless. Belcourt sold to the Tinney Family for a meager $25,000, for example.

The cottages were only used for six to eight weeks each year. The remainder of the year they were left with a skeleton staff to maintain the house and grounds through the winter. During that time, however, they were the residences of some of the wealthiest people in history. Lavish excesses were the norm in a society that admired conspicuous consumption.

At one dinner party, each guest was given a shovel and a pail of sand as a party favor. The pail and shovel were solid gold; the sand hid diamonds, rubies and other precious jewels. No expense was spared. At one gathering,

the men were all given hand-rolled cigars that had been rolled from hundred-dollar bills.

Meanwhile, the staff received pay considered well below average for the day. Hard work and long hours were the norm for staff of all ages. Employees were segregated from the employers as much as possible. They were treated often with less respect than horses, as horses were more expensive to replace. It was a world of bitter class differences.

The poor staff often met death or injury while maintaining the cottages. Mistreatment could even continue after death. When the *Titanic* sank, for example, the orchestra that famously played until the very end was never compensated for its efforts. In fact, all of the crew immediately stopped drawing a wage the moment the vessel dipped beneath the surface. The grieving relatives of the orchestra were sent the bill for their unreturned uniforms.

The cottages were run in the same manner. Given the harsh treatment, it's no wonder that the wealthy feared that their staff would rob them. While the wealthy were greeted at the front entrance, the employee entrance was much less pleasant. It often consisted of large iron bars so that even delivery people would have no direct access to the house.

It was an unpleasant experience at all times in the employee quarters of the houses. There are reports of staff being killed or maimed by horses or carriages or dying by accident in the kitchen. There was little thought given to them; they were simply replaced. However, their spirits are said to wander through most of the Preservation Society's properties.

Staff report a haunted tapestry hanging on the staircase at one cottage. Haunted staircases, haunted rooms and haunted artifacts are found at each of the major attractions. Staff have also reported hearing voices when there is nobody around. Most of the haunted activity tends to center on the staff areas—the staff quarters, kitchens, stables and basements. These are the sometimes-creepy "working" sections of the cottages. It was here that the bulk of the sudden accidents—the ones that left ghosts behind—would have happened.

The Preservation Society has acquired a number of these cottages and turned them into museums. Some projects were relatively minor, while others were massive undertakings. The Tea House at the Marble House, for example, had to be moved back from the eroding Cliff Walk in order to save it from falling into the advancing sea.

Today the cottages are a centerpiece of Newport's tourism industry. Tours run continually throughout the day, but be sure to check on availability. Some of the smaller houses are not open as often as the larger ones. There may also be special events at specific cottages. Many movies have scenes that were filmed inside of Rosecliff, for example, including *The Great Gatsby* and *True Lies*.

The wealthy summer visitors had financed the Viking Hotel to house their guests.

VIKING HOTEL

Mrs. Ballinger is one of the ladies who pursue Culture in bands, as though it were
dangerous to meet alone.
—*Edith Wharton*

Newport's summer cottages were designed to host lavish parties, but they were not designed for large numbers of guests. The inns and hotels of Newport were unable to accommodate guests that arrived to attend the parties. Accordingly, a group of wealthy investors built the Viking Hotel. The Viking opened its doors on May 26, 1926. It was named in honor of the Old Stone Mill at nearby Touro Park, which was believed by some to have been built by Viking adventurers.

The Viking became the hotel of choice for wealthy travelers. It still operates today and still attracts the rich and famous. President and Mrs. John Kennedy were guests there, as were many Astors and Vanderbilts. The Viking is a historic hotel that has recently undergone expansion and renovations.

Like many historic buildings with resident ghosts, the renovations have—at least temporarily—put an end to ghostly encounters. There was a room above a ballroom that had been nearly abandoned. It was used for

The front of the Carriage House, nicknamed "the Bells" by locals, shows the sad decay of a Gilded Age treasure.

storage—and ghosts. Witnesses say that the sounds of a party could often be heard coming from the space. There are no more abandoned spaces in the Viking Hotel due to its recent renovation. There are still ghosts that make themselves known from time to time, but it seems that the ghostly soirees have ended at last.

BELLS ON THE REEF

Glory is fleeting, but obscurity is forever.
—Napoleon Bonaparte

Brenton Point State Park occupies nearly ninety acres of what was once one of Newport's grandest estates. It was named in honor of Governor William Brenton (1600–1674). Brenton originally took possession of two thousand acres of "the Neck" section of Newport in 1639 and named it Hammersmith. Later, Hammersmith was divided in two, West Farm and Rocky Farm. Both have been subdivided repeatedly since colonial times. West Farm includes present-day Castle Hill, Fort Adams, the Eisenhower House (Eisenhower's "summer White House") and Hammersmith Farm (Kennedy's "summer White House").

With memorials to commoners, disasters and famous people alike, it is not uncommon to find an informal memorial service at Mariner's Memorial at Brenton's Point.

A memorial brick for the liner *Lusitania*, torpedoed during World War I.

A memorial brick for the crew of the *Andrea Gail*, the subject of the book and movie *A Perfect Storm*.

A memorial brick for Dizzy Gillespie, added by his daughter Jeannie Bryson.

Portions of Rocky Farm have become modern Brenton Point State Park. Renowned for its breathtaking scenery, Brenton Point is popular among kite enthusiasts. In the large field, a steady sea breeze attracts kite flyers of all skill levels throughout the summer. Each July, it is host to the Brenton Point Kite Festival. Kites of all kinds fly above the park, painting the sky with their bright, graceful acrobatics.

At Brenton Point, you'll find a mariner's memorial with bricks honoring fishermen, Newporters and others who loved the sea. Included among the bricks are some dedicated to the memory of those lost aboard the *Lusitania*, the crew of the *Andrea Gail* (portrayed in the novel and film *A Perfect Storm*) and the victims of the *Andrea Doria* disaster. Many individuals are memorialized here as well, including John and Robert Kennedy, Dizzy Gillespie and countless others. Nearby is a special memorial to the 217 people lost aboard Egypt Air Flight 990, which crashed off the coast in 1999. There is also the Portuguese Discovery Monument, which pays homage to the Portuguese navigator Miguel Corte Real.

On the edge of the woods at Brenton Point State Park lie the decaying remains of a once-fabulous cottage of the Gilded Age. Accessible by foot only, the decrepit structure is surrounded by chain-link fence designed to keep trespassers out. Signs warn that trespassing is prohibited; they also warn of danger. It is wise to obey the signs, as the building is extremely dangerous. Metal support beams have corroded and collapsed in the salty air. Concrete, stone and brickwork are collapsing into and around the building as nature slowly demolishes it. It is a reminder of the fate of even the grandest structure.

Locals have long referred to the ruins as "the Bells," but the cottage was originally known as "the Reef." The Reef was owned by copper magnate Theodore M. Davis. Davis was a renowned traveler, author, archaeologist and Egyptologist. He was most famous for his work excavating Egypt's Valley of Kings between 1889 and 1912. His team is most famous for discovering the tomb of Yuya and his wife. Davis was also noted for discovering artifacts that would lead later expeditions to the tomb of King Tutankhamen. Davis himself was unaware that more discoveries lie ahead. He is famously quoted as saying, "I fear the Valley of Kings is now exhausted." Artifacts from such tombs traditionally carried a curse. One of the most famous Egyptian curses is that of King Tutankhamen. Some believe this curse lingers at the Reef.

Davis had been born in 1835 and built the Reef in 1885. It was a shingle-and-stone Queen Anne villa built overlooking Brenton's Reef. Not only was it a magnificent mansion, it also housed Davis's art and antiquities collections. Among the works kept at the Reef was Davis's

Great Gilded Ghosts

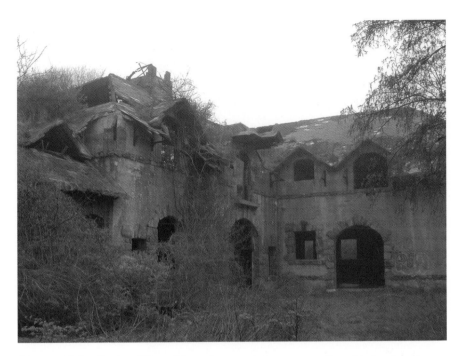

The rear of the Carriage House. Upper floors served as quarters for stable hands and as storage.

collection of Old Master paintings. He also maintained at the Reef "one of the finest private collections of Egyptian antiquities in the country."

Upon his death in 1915, his collections were bequeathed to museums and the Reef was purchased by Milton J. Budlong of Providence. In 1928, the Budlongs divorced and the family would never again live in the Reef. During World War II, anti-aircraft guns were placed around Brenton Point and the Reef was used to house gunnery personnel. The house was abandoned after the war and became the victim of decay and vandalism throughout the 1950s. In 1961, an arsonist set the villa ablaze and it was demolished in May of 1963. There are still remnants of the Reef at Brenton Point State Park. Park headquarters are inside a restored service bungalow. The ruins of the former stables and carriage house lie just outside of the main field at the park, a short walk from park headquarters.

Trespassing into the stables is forbidden and the park is closed from sunset to sunrise. However, local youths continue to frequent the grounds at night and vandalism remains rampant. Access to the upper floor of the structure became so dangerous that a brick wall has been built over the stairway to prevent access and injury to trespassers.

Left: Inside the Carriage House shows graffiti and vandalism. The support trusses have completely decayed; sections of the roof have collapsed.

Opposite: Indian Spring, now known as the Wrentham House, was in ruins until 1999. Today, the refurbished mansion is valued at about $17 million.

Like any abandoned house, the Reef Carriage House has more than its share of ghost stories. People claim to have heard the sound of voices from inside the empty ruins. Many have even claimed to hear horses and carriages clattering about the area of the ruins. What separates this haunted house apart from others is the gilded elegance it once possessed. It is unfathomable that a cottage of such rare beauty was allowed to fall into such a state of disrepair.

The property itself became a bitter contention in the divorce of its next owners. While other, smaller cottages with less spectacular views survive today, the Reef was cursed to remain largely uninhabited until finally destroyed by petty vandalism. Nothing remains of the main house today except the distant, fading memory of a gilded cottage shrouded in an ancient Egyptian curse.

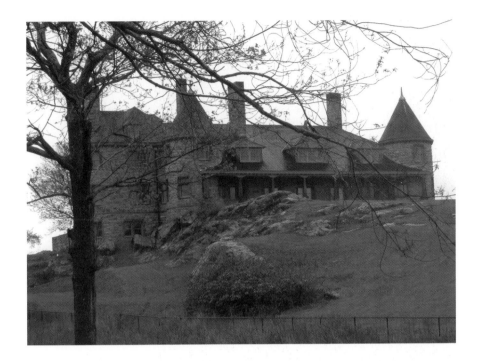

INDIAN SPRING

*Without an understanding of myth or religion, without an understanding of the
relationship between destruction and creation, death and rebirth, the individual suffers
the mysteries of life as meaningless mayhem alone.*
—Marion Woodman

The last salvageable abandoned mansion in Newport, the Wrentham
House, was finally purchased in 1999 by Dr. David Keefe. He began
making renovations to the mansion, purchasing the French Chateau–style
mansion Bois D'Ore. Dr. Keefe has since moved to Florida and has
decided to sell Wrentham house for approximately $14 million.

Now called the Wrentham House, this 14,400-square-foot mansion
sits on the highest point of Ocean Drive, on a five-acre plot. It is a rare
collaboration between architect Richard Morris Hunt and landscape
designer Frederick Law Olmstead. Wrentham House is a stone-and-
shingle masterpiece with eight bedrooms, guest rooms, thirteen bathrooms,
library, staff accommodations and a billiards room. Amenities include
nine fireplaces, a home theater, a wine cellar, an elevator and an eighty-
foot porch overlooking Ocean Drive. The grand ballroom even has an
orchestra balcony!

Morris and Law designed the cottage, then called Indian Spring, for Joseph R. Rusk in 1891. Rusk had defended the America's Cup successfully with his yacht, *Mischief*, a decade earlier and wanted a summer cottage overlooking the ocean in Newport. By 1999, Indian Spring looked like it would meet a similar fate to Rusk's *Mischief*.

Mischief successfully defended the America's Cup in 1881, commencing a short, bizarre history. Rusk was not an American citizen, which prohibited him from racing for the New York Yacht Club according to the club's bylaws. More concerned with victory than formality, the New Yorkers waived the citizenship rules for Rusk. Nicknamed "The Iron Pot," *Mischief* became the second all-metal yacht to compete for the America's Cup.

Under new ownership, *Mischief* was seized, suspected of smuggling between Canada and the United States in 1904. After two years of uncertain status, it was no longer registered as a yacht. In 1906, it was purchased by the Mayflower Oil Company, which used the hull as a barge for shipping oil. By 1929, it was abandoned. Several passionate Boston yachtsmen pooled their resources and bought the wreck to give it a proper burial at sea. On May 26, 1929, a U.S. Navy tug towed the hull offshore. Before an audience of twenty yachts from the most prestigious East Coast yacht clubs, an attempt was made to scuttle the vessel. When those attempts failed, the warship *Mojave* was forced to bombard the *Mischief*, finally giving it a proper burial.

Rusk's cottage nearly met a similar fate. By 1999, it had been renamed Wrentham House and had been abandoned for many years. It was hidden in a thick overgrowth and heavily vandalized. It was discovered to be part of the estate of a woman who passed away. She either never knew or never cared that she owned the property, which had been abandoned and forgotten.

It was during this time, as one would expect, that legends grew surrounding the ghosts that lived at the Wrentham House. Youngsters frequently trespassed at the abandoned mansion. Secluded by weeds and set back in the dark, it became a popular point of mischief and exploration. One of the trespassers, interested in exploration, had one of the most profound encounters to date.

Jamie Lurgio was exploring the property with a group of friends in the late 1990s. "I felt like I was part of the Scooby-Doo Crew," Lurgio explains. The property was falling to pieces. There was not a single piece of unbroken glass in the building; every window was smashed completely. In many areas, floors had collapsed from age, walls were vandalized and the place was slowly collapsing. The group entered the large ballroom with its peaked ceiling and orchestra balcony.

Great Gilded Ghosts

As others in the group slowly drifted away to explore other parts of the cottage, Jamie remained behind, completely transfixed by the ballroom. Suddenly, a large group of spirits entered the ballroom. They were "part impression and part shadow," as they silently filtered into the room and surrounded Jamie.

Jamie, who considers himself sensitive to paranormal activity, found himself in a room full of entities focusing their attention on him. Feeling crowded in, Jamie pushed his way through the otherworldly crowd to rejoin his group. He brought everyone back to the ballroom to find it empty. All of the spirits had vanished without a trace.

Who were these spirits and what did they want? Are they the shadowy echoes of a lavish party in a gilded mansion or could there be a more sinister reason for their presence? One guest who spent a great deal of time at Indian Spring was the noted mentalist Aleister Crowley. Crowley referred to himself as "the Beast," and was famously dubbed in the press "the Wickedest Man in the World."

Crowley traveled the world and is believed to have stayed at length at Indian Spring. He was one of the earliest occultists. He dabbled extensively (and proudly) with homosexuality, drug use and mystical black magic. Is it possible that Crowley himself opened a portal that remains unsealed today? Whatever the mysterious spirits are doing in the ballroom, they will soon be greeted by new owners as the refurbished cottage is sold. Who knows what ghost stories will be told and what level of paranormal activity they may encounter in the cottage once known as Indian Spring?

Four

Legendary Newport

PARANORMAL RESEARCH GROUP

Behind every man now alive stand thirty ghosts, for that is the ratio by which the dead outnumber the living.
—*Arthur C. Clarke*, 2001: A Space Odyssey

A small group of dedicated men and women created the non-profit Rhode Island Paranormal Research Group in 1984. Since then, they have been helping wayward spirits throughout Rhode Island. Anyone with ghosts can contact them for assistance. They work without compensation, using methods both modern and ancient. They maintain strict client confidentiality unless otherwise requested by the client.

Founder and director Andy Laird laid out the methods used by the group. The first step in any investigation is the client interview. At this stage, they assess personalities, family dynamics and other possible causes of phenomena. "Ninety percent of all cases have a natural cause," according to researcher Gene Miller. "It's not fair to waste their [the client's] time or ours looking for something that does not exist."

Andy Laird adds, "We have even referred cases to social services. Sometimes the only way someone can safely call for help is to claim to have a ghost." Through extensive questioning, the group tries to find a natural cause. "If someone is mentally ill and hearing voices, those are not ghosts and we cannot help," adds investigator Stephanie Miller. "We refer them to someone who can."

Each case is given a team leader. This person is the primary contact for the client and runs all aspects of the investigation. This person schedules people and equipment and ensures the smooth operation of the research team. The only person who can override the team leader is the team safety. This person is responsible for the safety of everyone involved. The safety

Some of the members of the Rhode Island Paranormal Research Group. James Shanley, Jason Maguire, Andy Laird, Stephanie Miller, Gene Miller and Maggie Florio.

can cancel an investigation or send someone home if safety is compromised for any reason. "At one investigation at Fort Weatherill, we had someone lurking around in the woods near the site we were at," said Andy Laird. "It was probably just someone who was curious, but we interrupted the investigation immediately." The team safety may send home a researcher who is sick or upset or even stressed. "Any weakness can be a hole that lets trouble in. Energy—especially negative energy—is a magnet for weakness. If you start out with a stomachache, a spirit can turn that into nausea," said Stephanie Miller.

Team members use the buddy system so there is better protection against danger and so that there is better verification of phenomena. A team may have a tech person, but duties overlap beyond each member's primary job on a case. Each case is unique and is handled by the team leader.

The next step is a preliminary investigation. A team of four to six people will perform a more detailed search for natural causes. They'll conduct a survey of the site and research its history. They'll also research the people involved. "It gets very personal," says Stephanie Miller. As research continues, the investigation becomes more detailed. Gene Miller points out, "We'll look for new plumbing, electrical work or underground wires,

weather patterns, illness—anything that may tend to explain what's going on."

Once they have eliminated natural phenomena, they'll try to communicate with the spirit. The team will include researchers, investigators, technical investigators and people sensitive to paranormal activity—known as "sensitives." There's no known way to directly measure a ghost. What can be measured is a ghost's effect on the environment. As spirits interact with the environment, they can create changes in temperature and in the electromagnetic field. By using modern equipment to measure these changes, they can sometimes communicate with ghosts.

All sensitives enter a mentor program with other sensitives. "We can all run. Some have more natural ability than others, but we can all do it. Training helps the runner to be more efficient and faster. It's the same with sensitives," said Stephanie Miller. New sensitives shadow more experienced sensitives to learn the procedures and to sharpen skills. Stephanie Miller has seen many ghosts, while group founder Andy Laird has seen only two. "I don't want to see dead people," he says.

An incredible amount of technology is available to detect fluctuations in electromagnetic fields, ion fields, temperature changes, humidity changes and radiation. They also use night-vision devices, closed-circuit television and motion detectors to track activity. Of course, everything is recorded using digital-sound recorders, still cameras and video cameras.

Sensitive Maggie Florio is particularly adept at communicating with spirits using equipment. "We start out asking yes-or-no questions and get the spirit to respond through the equipment. We'll get the ghost to move the needle on the meter to reply," Laird explains. "We try to eliminate all interference; turn off all lights. If possible, we turn off the main power supply so that we can't get false readings," adds Gene Miller. Some spirits even develop a signature electromagnetic-field pattern that can be recognized, a sort of Morse code, helping the team to identify them.

"When I arrive, I try to reassure the spirit that we are not here to harm or disrupt it. I talk to it as I move around the site. I try to let it know that I will treat it with respect," says Stephanie Miller. "I also let it know that I expect to be treated with respect. I tell them, 'I will not allow you to harm me,'" she adds. Laird points out that ghosts, like people, have moods. "Sometimes they are trying to tell us, 'Not now.' Having us in their space can be like having the in-laws over. Sometimes it's great; sometimes you've had enough and you want them to go. Sometimes a ghost will make that point by throwing a twenty-five-pound window frame."

Some spirits will lie and play pranks. They'll challenge and test the investigators. Usually, the team finds that they really want the attention

Equipment used to detect the presence of paranormal activity and to communicate with ghosts.

and the best way to get the spirits to behave is to threaten to leave and not return. They are looking for a voice and the investigators may be their only chance to find one. "They're stuck in time at the moment of death," says Laird, "they are often unwilling to let go."

Less than 2 percent of all spirits are actually malevolent. Most are misunderstood or lost. They may still be dangerous, but the evil intent to do harm is rare. A sensitive can shield himself or herself and others from most danger. Sensitive Gene Miller is particularly adept at shielding others, even across distances. On one occasion, a mischievous spirit was harassing some team members. Andy sensed the problem from the far end of the house and told Gene to "give him a whammy." At that moment, video recorders on the scene show a shadow drift away.

However, the Rhode Island Paranormal Research Group (RIPRG) will not deal with demons. Those cases are referred to local clergy for exorcism. Several local priests and nuns are supportive of the work RIPRG is doing. Some have even been involved in investigations. "It's important to know your audience," says Stephanie Miller. "Some spirits might take offense at some of our modern ideas and methods." A spirit that was raised to fear witches will fear an investigator who works with traditional tools like crystals,

herbs, incense, oils, talismans and other objects associated with witchcraft. One spirit was evidentially offended that the man living in his house was a seamstress. The team was able to demonstrate to the spirit the high caliber of his work, bringing peace to the spirit and the house.

"We are fighting against Hollywood," Andy Laird says. Even reporters who are assigned to the obligatory Halloween news story can have preconceived notions. In one such instance, a cameraman and reporter were assigned to cover an RIPRG investigation at the Sprague Mansion in Coventry, Rhode Island. The reporter was clearly skeptical of the group, but during the course of the evening, the camera began to malfunction. It worked fine outside, but not inside. When they came inside, the reporter felt tugging at her clothes. When she realized that there was nobody there, she became nervous and insisted on leaving without completing the story! Though she was scheduled to stay for most of the night, she only stayed for about twenty minutes.

The media and culture have made people unwilling to accept ghosts as a part of existence. "We develop a layer around us that prevents us from seeing them," Stephanie Miller says. "Children haven't had time to grow that layer, yet. They are far more likely to talk about seeing a ghost." Gene Miller adds, "When you're a child, they say it's just your imagination. When you're a teen, they tell you you're weird. Adults learn to keep their ghosts secret." In fact, ghost stories abound from all cultures that embrace ghosts as real. Even our own culture, once upon a time, was willing to accept ghosts. That may be why so many of our ghost stories come from our early history. There may be just as many new ghosts out there, but people are now too embarrassed to talk about them.

While our ghost stories can tell a lot about our culture and beliefs, perhaps our lack of stories tells something just as important. Once upon a time in America, we sang songs, gathered as a community and danced at the local hall. We told each other stories that have today become a part of our folklore. Some were real and some were made up. We were all writers and storytellers. Today, our shortage of new ghost stories is a troubling development within society. After all, the stories we tell today are society's epitaphs tomorrow.

If you feel that you need help from RIPRG, or if you just want reassurance that there are still people hopeful enough to believe, you can visit their website (listed in the Spirit Guide at the end of this book). There you will find a large and diverse group of people who have not closed their minds to the ghosts that still walk among us. You can also learn about their public cases (information that may tend to compromise client confidentiality does not appear), their equipment and methods, ghost-hunting tips and even a place to post your own ghost stories.

MENTALIST RORY RAVEN

Welcome back my friends
To the show that never ends.
We're so glad you could attend.
Come inside! Come inside!
—Emerson, Lake and Palmer, "Karn Evil 9 First Impression"

Mentalism traces its roots back as early as the 1572 performances of diplomat Girolamo Scotto. Most of the techniques of the modern mentalist, however, date to the nineteenth century. Mentalists will seemingly use precognition, mind control, hypnosis, clairvoyance, psychokinesis and other mystical arts as part of their act. Mystics generally fall into two types—those who claim that they are truly channeling paranormal powers and those who freely admit that there is a trick involved.

Mentalists set themselves apart from magicians, generally. Many insist that mentalism is a different art form altogether. There's also an incentive to avoid magic on the part of the mentalist, as it tends to increase the skepticism of the audience. People who believe there is a magic trick involved are likely to focus too heavily upon the trick and miss the skills involved in the act. "People will say, 'I know how you did that,' after a show," says mentalist Rory Raven. "They're convinced that they've figured it all out."

"I'm a showman who appears to do things that are psychic. So there are elements of psychology, theater, magic, con artistry, salesmanship and showmanship," Rory claims. He points out at the beginning of his show that he does not believe in ESP and the like, or at least he has seen no evidence that supports it. "There is nothing paranormal about what I do. I'm not psychic, and I'm very skeptical of people who make psychic claims. When something happens onstage, it's because I have made it happen in one way or another, and I know why it has happened. It may be mysterious to the audience (I hope!) but not to me."

Rory claims that there is nothing that he does that can't be learned by anybody who is willing to make the effort. He quotes famous mentalist Joseph Duninger, who said, "Any child of ten could do this—with forty years of experience." It's as simple as any other art form—writing, drawing, magic, music. It takes practice, dedication and study more than anything else.

Rory became interested in mentalism at a young age. "Ever since I was a child I was fascinated with stories of ghosts, prophecies, magic. I was a very solitary, imaginative child who lived very much in his own world. Someone gave me a magic set for a birthday or Christmas, and I fooled

Mentalist Rory Raven on stage in Newport.

around with it for a few weeks before losing interest. Many years later, in my twenties, I came back to some of those early interests, now armed with some knowledge of psychology and theater." Years of hard work and study have helped Rory create an impressive show.

"I've been doing colleges and small theaters lately. I think that the 'parlor' setting works well for me. Give me fifty or so people for forty-five minutes and they'll have a good time." People are amazed when he appears to read their minds or predict what they will do. This brings up one of the most fascinating aspects of the paranormal. Even in the twenty-first century, we are fascinated by it.

Most Americans will claim not to believe in any of it—ESP, ghosts or magic. Even knowing that the magician is using tricks to perform does not detract from his show. We know that he is not truly tapping into some great mystical power to alter reality. It is a trick, and we can't wait to be fooled. We love ghost stories, though we do not believe in ghosts. We want to believe, somewhere in our hearts, that it is all at least possible. Perhaps, denying that, we would have to question our very soul.

On the other hand, perhaps we really do believe, deep down inside. In fact, at a recent performance at Newport's Firehouse Theater, two patrons had to be coaxed into staying once they discovered that Rory Raven was

performing. They were absolutely terrified that he would read their minds. Did they have something to hide? Were they, modern Americans, so convinced that a man held this power?

Ghost tour guides on the Old Towne Ghost Walk in Newport will start the tour with the question, "Who believes in ghosts?" Naturally, people appear skeptical. Hardly a tour ends, however, without someone asking real, important questions about ghosts. Are we—scientific, enlightened, modern men—still so deeply moved by ghosts and paranormal phenomena? Whether we believe or not, it is a subject that is universally fascinating to mankind. It is an integral part of who we are.

If you want to experience the fascinating world of mentalism, Rory Raven performs throughout the region. If at all possible, catch his show and be prepared to have your mind read. He also operates a ghost tour in Providence, Rhode Island. The Providence Ghost Walk, the city's original ghosts and graveyards walking tour, explores the strange history of Providence, with tales of ghosts, vampires, Edgar Allan Poe and H.P. Lovecraft. With the tour, Rory has received an Independent Research Grant from the Rhode Island Council for the Humanities. He's even had a couple take the Providence Ghost Walk for their first date, and now they're married!

BRIDGE TO NOWHERE

The grave is but a covered bridge leading from light to light through a brief darkness.
—*Henry Wadsworth Longfellow*

Today, the drive to Newport from the west will take you along Route 138, as it has for years. As you leave the mainland, you must cross two major bridges. The first of these will take you to the island known as Conanicut. Named for a Narragansett chief, it is home to the picturesque town of Jamestown.

This first bridge is called the Jamestown-Verrazano Bridge. It is a modern, unremarkable structure that takes you over the west passage of Narragansett Bay. To the north you can see the recently restored Plum Beach Lighthouse, Quonset Point and Providence in the distance. To the south you will find Rhode Island Sound and the Atlantic Ocean.

This modern structure opened in October 1992, finally ending the useful career of the original Jamestown Bridge. The Jamestown Bridge is today little more than a memory. Its steel has been recycled and its concrete has been dumped in two locations offshore to create artificial reefs. At this writing, there are small sections that are still being demolished.

The Jamestown Bridge, moments before explosive charges detonated, destroying the main span.

Initially, there was a great deal of resistance in Jamestown to the idea of a bridge. As one booklet that circulated at the time opined:

> *To the Island of Jamestown it would attract a class of picnickers, hot-dog stands and other undesirable elements, and would merely serve as a pathway to the ferry to Newport...It is the opinion of those who have followed this project that it would commercialize and cheapen your community.*

Opinions in Jamestown were drastically altered in September 1938 by the great hurricane of that year. The destruction caused to the existing ferry service by that storm convinced most residents to approve the bridge by a vote of 240 to 23 that November.

The 6,892-foot span was constructed on an accelerated time schedule. After eighteen months of construction, it was opened to the public on July 27, 1940. The accelerated construction and dangerous working conditions contributed to the deaths of many workers on the project. People desperate for work during the Depression were willing to work long hours under dangerous conditions. Legend sprung up that one worker fell to his death and was sealed up in the concrete of one of the support structures for

the bridge. It was said that he fell and was impaled upon the steel frame just as the concrete began to pour. Unable to save him, workers made the unfortunate decision to entomb him within the bridge. Several workers were injured or killed building the bridge. Their bodies may not have been entombed within the concrete, but their blood and sweat went into building the incredible span.

In reality, nobody was entombed in the concrete. Like many legends, this one is based partially on a true story. It is true that the captain of a construction tug did fall to his death, impaled on the reinforcing steel bars of the concrete forms, but his body was recovered and buried in his hometown. Perhaps his spirit continued to haunt the Jamestown Bridge until its destruction, nonetheless.

Legends abounded for decades that his spirit was one of many that inhabited the bridge, haunting sailors, drivers and workers. Some sailors would speak of sailing under the new bridge without problem only to find strange winds under the old bridge. "The wind was spooky and swirly under the older, lower Jamestown Bridge—as if some ghosts were affecting it," one sailor wrote in his journal.

Drivers and workmen on the bridge itself often spoke of apparitions in the fog, of a strong sense of a presence on the bridge and of strange premonitions that they claim saved their lives. One recurring apparition was that of a seaman in a dark blue uniform. This particular apparition has long been suspected of being the spirit of a man who died during construction of the bridge.

When completed, it was the longest bridge in New England, constructed at a cost of $3,002,118. It was a toll bridge until June 28, 1969, when the Newport Bridge opened and began charging tolls. It saw a steady increase in traffic throughout its long life, particularly once the Newport Bridge opened. It forever changed both Jamestown and Newport.

If you've ever driven across the old Jamestown Bridge, you probably have strong emotions about its demolition. Nearly 7,000 feet long, the bridge had only two narrow lanes, with a total road width of only 22 feet. The peak of the bridge consisted of a nerve-wracking metal grate with a view to the water 135 feet below. The superstructure of the bridge looked as though it came straight out of a giant Erector Set.

Though there were no traffic fatalities on the bridge until 1951, its record steadily worsened with increasing use. Particularly after the opening of the Newport Bridge in 1969, traffic roared along the narrow lanes, causing frequent accidents. Thanks to the tight lanes, many vehicles that frequented the area lacked driver's-side mirrors. Tourists were unaccustomed to the special requirements of driving on a metal grate that was frequently wet and slippery. This resulted in many fatalities and injuries.

Indeed, the bridge shook and rattled with traffic from the outbound lane, unsettling those stuck inbound with a view of the sea below. Perhaps more unsettling was the structure's slight—but noticeable—lean southward. Decades before the bridge's demolition, locals often spoke of the inevitability of its fall into the bay. Jamestown students who bussed across the bridge to Newport schools began noticing that buses waited at the base of the bridge and crossed the bridge one at a time. The reasoning was obvious: the bridge could not safely support the weight of more than one bus. Students also whispered that when the bridge collapsed, officials wanted to ensure that they would lose no more than a busload of students and not an entire generation.

Legends surround the Jamestown Bridge. According to one tale, a state trooper had to drive a woman across while she cowered in the back of the car with a blanket over her head. Some divers claim that some of the pilings beneath the water, while the bridge was still in use, had gaps big enough to wave your hand through.

The legendary Jamestown Bridge—also called "the bridge to nowhere," "Jamestown's Folly" and "the Hail Mary Bridge"—slipped quietly into disuse in October 1992. By then, its age and obsolescence made it unusable to heavier vehicles such as fire trucks. The state looked for anyone willing to demolish the bridge—even requesting movie producers to demolish it for a movie. Nobody ever took the state up on its offer and eventually the U.S. Coast Guard declared the structure a hazard to shipping.

On April 18, 2006, the first of a series of planned explosions demolished the bulk of the bridge—a $19.5 million project. Its legend and legacy will live on in the hearts and minds of all who traveled across those steel grates. Today, many whose knuckles gripped white at the steering wheel as they approached the Jamestown Bridge look back nostalgically. Sure, it was dangerous, terrifying and obsolete. Yet, it held a certain familiarity, charm and, above all, character that is sadly lacking in its replacement.

YESTERDAYS

Yesterday brought the beginning; tomorrow brings the end.
—*Unknown*

Newport is a great place to visit. Millionaire's Row on Bellevue Avenue has one of the largest collections of mansions in the world. The city has more colonial buildings than any other city in America. The Atlantic Ocean, Narragansett Bay and Newport Harbor provide some of the most spectacular scenery anywhere. Newport also has a phenomenal collection of museums, art galleries and theatres.

The tremendously valuable Goddard shell serves as the artist's signature.

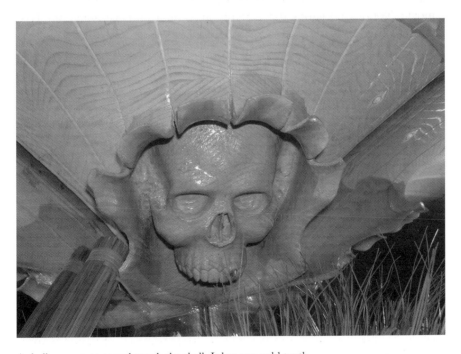

A skull appears to tear through the shell. It has one gold tooth.

Of course, there are also restaurants, pubs, taverns, bars and nightclubs to satisfy any taste. This is a natural effect of Newport's history. As a sailing and shipping community, Newport's wealthy captains developed exotic tastes from around the world. They brought these recipes back to Newport. Religious refugees from around the world also added to the culinary diversity. Today, tourists, guest workers, immigrants and sailors from around the world continue to demand an unusually eclectic mix of restaurants.

One of Newport's great finds is the restaurant Yesterdays, with a bar called "The Place." Here you will find great food at reasonable prices right in the heart of historic Newport. Situated on Washington Square, near the Old Colony House, Yesterdays is a popular restaurant with locals. Frequented by the extremely wealthy, yet affordable to the average family, it is a wonderful dining experience steeped in history.

Originally built in the 1930s as the Capital Restaurant, the building has undergone many transformations. There was once a bowling alley in the basement. It served as a locker facility for sailors coming off the base. Buses dropped them off in Washington Square in uniform, as they were required to wear uniforms at all times on base. Once in Washington Square, they hit the locker and shower facilities to change into "civvies" to go into town.

It has been completely refurbished as a great restaurant. The walls are adorned with historical photos and documents from Newport. In fact, the management at Yesterdays maintains a deep commitment to preserving our local history. One of the finest historical pieces on display is a Goddard shell.

The Goddards were famous furniture makers, of Goddard and Townsend fame. It is a Goddard piece that set the record for the highest price ever paid for a piece of furniture—a six-shell bookcase sold for $12.1 million! The furniture often featured concave and convex blocks and shells. Over 120 years, twenty-one family members made furniture. Each of the family members had a specific symbol, which would be carved on their work as a signature. The shell inside Yesterdays bears one family signature—a human skull with a gold tooth. This is the first Goddard piece publicly displayed since the 1800s. Should you dine at Yesterdays, be sure to ask for a peek at the Goddard skull above the corner table.

During dinner, be sure to listen carefully. The basement is haunted with the sounds of its past. People have claimed that they could clearly hear the sounds of bowling coming from the basement. Others claim to hear the distinct sounds of a locker room. Ghosts, it seems, are to be expected in a place called "Yesterdays."

A faded sign warns of danger at Teddy Beach. The sea creature slipped away to hide in the pilings visible in the distance and was never seen again.

OF THE BRINY DEEP

And if you gaze for long into an abyss, the abyss gazes also into you.
—Friedrich Nietzsche

On Tuesday, July 30, 2002, summer's sweltering heat reached a peak of ninety-one degrees. The continuing heat that had oppressed the region all week drove many people to area beaches, including Teddy Beach in the Island Park section of Portsmouth, Rhode Island. Among those seeking relief at Teddy Beach that afternoon were Fall River, Massachusetts residents Dennis Vasconcellos; his fiancée, Rachel Carney; Joey Maillox; and Tracy Roberts. Their experience that day would make news around the world.

Island Park is a tight-knit working-class community on the northernmost portion of Aquidneck Island. It was once a flourishing community of speakeasies and burlesque halls catering to travelers on steamships and locomotives. There was even a large amusement park. The community was devastated, however, by the hurricane of 1938 and never fully recovered.

It's the kind of picturesque New England fishing village that would have long ago been snatched up by contractors looking to build hotels

and condominiums, but for its vulnerability to storms. Several taverns and restaurants line the main street, including one of the most famous seafood stands in Rhode Island, Flo's Clam Shack. The neighborhood is dominated by the Sakonnet River, Pirate's Cove and Narragansett Bay. Surrounded by water, its very picturesque beauty is also its greatest vulnerability.

In the heat of that summer day in 2002, it also became a site of great terror. Teddy Beach was moderately crowded because of the high temperatures, but since it was a Tuesday, it was not jammed with people. Several people were fishing from shore as well as from a nearby pier; others were swimming or playing in the soft sand. Rachel Carney was swimming in the water beyond a faded sign that read "Danger."

Suddenly, danger reared its ugly head in the form of a bizarre sea creature. As Carney tells her story, "I was deep out in the water and kept hearing this hissing sound. Then I saw its head come up showing me its big teeth. It kept rolling while it was swimming and knocking into my feet. I just froze."

Carney's fiancé swam to her. He grabbed her from behind and told her, "don't look back." "This thing was big," Vasconcellos says, "I mean its head was almost the size of a basketball. I just kept backing in to shore, but it was looking at me and hissing. The other people around there were pulling their kids out of the water."

Witnesses describe the creature as being about fifteen feet long, greenish-black with a white belly and armed with four-inch teeth. "I just saw them [Carney and Vasconcellos] swimming as fast as I've ever seen anyone go. Then I saw this big, big thing spinning around the two of them. It kind of looked like an eel to me, but I'm sure it wasn't because it was so big and had a white belly," Joey Maillox told reporters. Maillox had just caught a fish and slipped on the rocks near the beach, cutting his legs. He wonders if the scent of blood might have initially attracted the sea creature.

Scientists are baffled by the description of the creature. Aquaculturist Ed Baker, of the University of Dartmouth's Center for Marine Science and Technology, says that the creature described is unlike anything he knows of. It is possible that the creature was swept along the Gulf Stream from its tropical home. Once Carney and Vasconcellos had safely reached land, the creature swam along the shore and disappeared among some pilings on the far end of Teddy Beach. Perhaps it was a misplaced tropical creature, destined to perish in the cold, brackish water of Island Park. Then again, perhaps it had moved into the area to breed. As Vasconcellos warns, "I don't want to seem scared, but people should know to keep their children close, because that thing was definitely big enough to kill us. I thought I was dead."

The Island Park Sea Creature is not the first modern sea monster sighted in Rhode Island, and will probably not be the last. The Gulf Stream draws countless tropical fish north each summer. As the summer fades, these creatures congregate in bays and inlets throughout New England. Narragansett Bay is one of the most inviting of these. It has few streams running into it, making it one of the saltiest bays along the eastern seaboard. Reaching depths of 180 feet, it is also the deepest bay along the eastern seaboard, with plenty of room to hide even the largest creature. Divers often encounter a tropical paradise by early September.

Perhaps it was another such tropical creature that spawned the legend of the "Block Ness Monster" on Block Island. In this case, a sea creature was captured by fishermen J.T. Pinney and Gary Hall. However, the carcass has mysteriously disappeared. In late June of 1996, the two men were fishing for monkfish aboard the *Mad Monk*. They pulled up their net and found a bizarre creature from the briny deep. It was a fourteen-foot serpentine skeleton. It had a narrow head, weird whiskers and vacant eye sockets. The creature appeared to be made up mostly of cartilage.

The fishermen displayed their unique catch on the stone breakwater near where the ferry docks. For two days, it drew a steady stream of curiosity seekers. "Probably more people walked down there in two days than in the whole century, just about," said Block Island resident Chris Littlefield. Among those who encountered the creature was Lee Scott, a biologist from New York. Scott had the creature frozen to prevent further decay. He had planned to ship it to the mainland for examination at the National Marine Fisheries Service in Narragansett. Unfortunately, it vanished before it could be examined by scientists.

The mystery has never been solved. Rumor has it that the remains were taken by locals who did not want to see the creature removed from the island. Some say the remains were a basking shark, which can grow to forty feet long. Perhaps the fishnappers are right. In a world of scientific answers, perhaps we need a little mystery. There are mysteries out there worth preserving. Whether it's the Island Park Sea Monster or the Block Ness Monster, mystery is only minutes away from Newport.

SCANDAL AND MURDER

The cheapness of man is every day's tragedy.
—*Ralph Waldo Emerson*

Newport has seen more than its share of scandal. With some of the most flamboyant personalities, it is almost expected. One of Newport's most

flamboyant personalities was Doris Duke, the eccentric heiress. She was born into the Duke Tobacco fortune, which was estimated to be $80 million. Ninety percent of all tobacco used in America came directly from the Duke trust. By the time she inherited her father's estate, legal fees, the Depression and anti-trust laws had whittled the estate to $30 million.

She was called the "Million Dollar Baby" in the press when she inherited such a massive sum of money during the Depression. Her father had always warned her to trust nobody because of her wealth. In fact, his death from pneumonia is rumored to have been hastened by his wife. Some claim that she left him locked away from others, uncovered in the winter with the windows open to speed up her inheritance. Doris was able to sue and win financial control of the estate, earning her inheritance at age thirty.

She had also been kept protected for fear of kidnappers. By the time she was thirteen, she towered over others at six feet tall and had a pronounced chin. She eventually had plastic surgery on her chin. Her awkwardness and unusual upbringing made her eccentric, to say the least.

She met and married super-stud playboy Porfiro Rubirosa. Legend has it that she actually bought him from a friend for $1 million. He had been a reputed Dominican hit man and diplomat. He had a reputation as a lover with unusually large qualities. In Newport, restaurant staff began to refer to large peppermills by the slang term "Rubirosas."

Rubirosa was clearly interested in being a wealthy playboy. It is said that he fainted at the wedding when presented with the ironclad prenuptial agreement. The marriage lasted only one year, after which Rubirosa wed another wealthy heiress. Doris had several affairs after her divorce. Her partners included Louis Bromfield, General George Patton and Errol Flynn.

She vehemently battled the city of Newport over the right of way on her property at Rough Point. State law guarantees public access to the shore. But Doris did not want the commoners wandering at will through her scenic backyard. She did everything she could to hinder the Cliff Walk.

In October 1966, she was involved in a fatal automobile accident. Her interior decorator, Edward Tirella, was driving the station wagon; Doris was in the passenger seat. Witnesses claim that the two had been arguing heatedly all night long. When Edward got out of the car to open the heavy iron gate at Rough Point, the car lurched forward, dragging him across the street and crushing him against a tree. At first, Doris claimed that she was not driving, but later changed her story to say that her foot "slipped" onto the accelerator.

Newport Police were completely satisfied with her alibi and concluded that an investigation was not warranted. One week after manslaughter

charges were dropped, Doris gave the city $25,000 to fix the Cliff Walk. The chief of police was able to retire a month later and Tirella's family received a sizable settlement from the civil suit. Doris then created the Newport Restoration Foundation in 1968, which still owns many historic buildings that have been restored.

Newport's next big scandal took place in 1982, when Claus von Bulow was convicted of attempting to murder his wife, Sunny. He was sentenced to thirty years in prison for injecting her with insulin. The insulin left Sunny comatose but alive and Claus inherited her fortune.

Claus hired Harvard lawyer Alan Dershowitz to appeal his case. Dershowitz was able to cast serious doubts on the prosecution's evidence and in 1985, Claus was found not guilty of all charges. However, many in the family maintain that he is guilty. Sunny's daughter, Cosima, maintained her father's innocence during the trial and was disinherited by her maternal grandmother for it.

Claus agreed to renounce all claims to Sunny's $75-million estate in exchange for Cosima's reinstatement into her grandmother's will. Today he lives in London, where he writes theatre reviews. Dershowitz wrote a book about the incident. His *Reversal of Fortune* became a major motion picture starring Jeremy Irons and Glen Close. Today Sunny remains in a coma in New York at Columbia-Presbyterian Hospital.

Not all of Newport's scandals involve the rich and famous. In the early 1990s, Adam and Elena Emery went to a local amusement park in Warwick. As they sat in their car at Rocky Point Park, another vehicle struck theirs and the drivers fled the scene. Enraged, Adam gave chase, eventually catching what he thought was the vehicle and driving it off the road. As he went to confront the driver, Elena reminded him to take a hunting knife for protection.

But the car that Adam approached had not been the car that had struck his vehicle. This innocent driver now found himself run off the road and confronted by a man with a knife. Adam reached into the driver's window as the man sped off. Adam claims that he acted in self-defense, stabbing the man to prevent himself from getting injured by the speeding car. The man died from the stab wounds and Adam was tried for murder.

The jury found Adam guilty of murder on his thirty-first birthday. Released pending sentencing, the Emerys had a last meal at a local Burger King. Their car was found atop the Newport Bridge, indicating that the couple had committed suicide—but had they? Adam had been studying Italian since his arrest and had relatives in Italy who could have taken him in. Rhode Island police speculated that the two had jumped bail, and an international manhunt was launched.

The picturesque Newport Bridge is the longest span in New England. Opened in 1969, it has been the site of many suicides. The Emerys' car was found abandoned on the bridge, Elena's remains were found below. What became of Adam?

Eventually, some of Elena's remains were found at the bottom of the bay, but no trace of Adam has been located. Perhaps he is somewhere at the bottom of the vast sea; perhaps he is living comfortably in Italy. Many believe that he may not have joined his wife as promised in their apparent suicide pact.

One final major scandal that rocked Newport has slipped into obscurity. It was the navy sex scandal of 1919. The details of the scandal were so lurid that the *New York Times* story about testimony in the case simply stated, "Details unprintable." What sets this scandal apart from others was that it was a gay sex scandal.

Newport in 1919 had a notorious homosexual population. A group of sailors were particularly flamboyant. They appeared in drag throughout Newport and called themselves "the Ladies of Newport." The navy finally decided that it must put an end to what it considered immoral behavior.

The navy hired undercover agents to get evidence against suspects by whatever means necessary. The navy agents managed to entrap sailors by engaging in homosexual activity with them. The scandal reached national attention when the investigators turned their attentions on a prominent Episcopal minister.

Hollywood legend has it that werewolves attack only during a full moon. Real werewolves were not so constrained.

A Senate investigation of the incident found the navy's actions in the case "reprehensible." The assistant secretary of the navy, Franklin D. Roosevelt, claimed to be unaware of the investigation. In the end, many careers were destroyed in one of the navy's most torrid scandals.

WEREWOLVES OF PORTSMOUTH

Welcome to my nightmare. I think you're going to like it.
—*Alice Cooper*

In 1832, the town of Portsmouth created the Portsmouth Poor Asylum to commit those who required assistance "by their evil courses." As with most poorhouses of the day, care for the poor was auctioned off to the lowest bidder with no concern for the quality of care that would be provided. After all, the poor were considered responsible for their own plight.

In fact, the goal of the poorhouse was to make life so miserable that nobody would want to stay. There were strict regulations with swift, harsh punishments. All able-bodied individuals were given "busy work for idle

hands." The Poor Asylum contained a large farm that raised chickens for egg production, sheep for wool and meat and pigs. Apples and onions were grown and butter was produced. Because of this, it was commonly referred to as the "Poor Farm." Residents also harvested seaweed—which was sold by the load—and oakum.

Oakum consists of recycled fibers culled from worn-out hemp ropes and loosely twisted into a yarn. The ropes had to be cut into two-foot lengths and then the fibers would be painstakingly peeled apart and rolled back into a long strand of yarn. It was tedious work, hard on the fingers. There were no tools used to peel apart the fibers, which were held together with pine tar. Oakum was used primarily as calking for ships, but the material could also be used to stuff pillows and mattresses.

The work was primarily done by slaves, prisoners and poorhouse residents. In fact, since nobody would willingly do the job, the phrase "picking oakum" became slang for getting into trouble. In 1849, residents produced 1,601 pounds of oakum at 2¼ cents per pound. Usually, residents tended to the farm. Picking oakum was reserved for winter days, inclement weather or as punishment.

There was no training for keepers at the Poor Asylum. All punishments were at the discretion of the keepers, with no review or appeal. The negative bias toward residents increased the severity and frequency of punishment. Mixed among the poor were the insane, elderly and handicapped. There was no separation of the different populations and there was inadequate supervision, resulting in many injuries and fatalities. Untrained and understaffed, the staff resorted to excessive abuse in an attempt to control the residents through fear.

Many deaths at the Poor Asylum were a direct result of abuse by both staff and residents. In Thomas Hazard's *Report on the Poor and Insane in Rhode Island*, there is a record of a complaint by an elderly resident, Caroline Albro. "I have suffered much for fear of the insane," she said, "and sometimes cannot sleep, for fear of being attacked by them." In fact, Mrs. Albro was attacked on two occasions at the Poor Asylum. In one instance, she had her arm broken by an insane woman who beat her with a fire hook. In another instance she was beaten with a chair while rescuing a one-year-old child from the same woman.

It was not until an elderly woman was beaten to death that something was done to protect other residents. A woman attacked Mrs. Cornell, an eighty-six-year-old resident, with a broomstick. Mrs. Cornell died shortly thereafter, "hastened by the beating she received." For the attack, the insane woman was chained up, along with other victims of mental illness.

At the time, insanity was thought of as something to be endured with little compassion. The insane were routinely chained or bailed in sackcloth. Those

prone to soiling or wetting themselves were kept without clothing, usually away from the fire, even during the winter months, "for their own protection."

Memoirs of William R. Fales have given us a personal glimpse into the harsh reality of the Poor Asylum. Mr. Fales was poor and crippled. As such, he wound up in the care of the Portsmouth Poor Asylum. In a letter dated June 8, 1849, Mr. Fales writes, "I have been carried out in the air once this season; it was the 17th of May, and I enjoyed the scene considerably." Even more disturbing is a passage from his letter of September 10, 1849:

> *My right arm has been so lame as to deprive me of the use of it for a number of days. I could not even feed myself. The flies in my room were, and still are, numerous and troublesome, which renders my situation more distressing, as I find it very hard to keep them off with my poor, feeble left arm. I also find it difficult to keep them off whilst writing; and though my suffering is greatly increased whenever my right arm becomes useless, yet it is the Lord's will that it should be so.*

All that remains of this terrible place is a well, a cistern, some foundations and a small cemetery filled with unmarked graves. The Portsmouth Poor Asylum closed in 1929, after ninety-seven years of what would today be considered human rights violations. It sits—overgrown by brambles and bittersweet—on the southwest corner of property now owned by Raytheon. It's a sad strip of land that was owned by Rebecca Cornell until her death in 1673 and then owned by her son Thomas until his execution. In addition to the real horrors of the Portsmouth Poor Asylum, more than one legend arose from the site.

In one particularly strange and now obscure legend, the poorhouse was home to a werewolf. In the 1800s, local legend tells of a priest who went insane and committed a gruesome murder. Rather than being led to the gallows, he was given perhaps a more harsh punishment. He was committed to the Portsmouth Poor Asylum. The claim was made that he was a werewolf. He was not in control of his actions at the time of the murder because he had assumed the form of a wolf. He lived out the rest of his days at the Portsmouth Poor Asylum, most likely chained and bailed in sackcloth for his own protection, his blood-curdling screams mixing with the screams of other insane residents warehoused with him.

Somewhere in that small, unmarked cemetery lie the remains of those who died at the poorhouse. Most slipped away quietly in the cold of the night, often during the winter. Often, they died as a direct result of neglect, starvation and beatings from both staff and other residents. The poor, the insane, the handicapped, the elderly and even the werewolf have all been

buried together, hopefully to rest in peace. There are legends whispered around the area that speak of the restless spirits screaming in the night—and of even one werewolf who haunts the woods and thick undergrowth that was once the Portsmouth Poor Asylum.

VAMPIRE CAPITAL OF AMERICA

When other little girls wanted to be ballet dancers, I kind of wanted to be a vampire.
—Angelina Jolie

Rhode Island is known as the vampire capital of America. Of the twenty vampires recorded nationwide, six called Rhode Island home. In fact, three resided within the town of Exeter. America's most famous—and last—vampire was Mercy Brown of Exeter. Others before her set the precedent.

Rhode Island's first recorded vampire emerged in 1796 in Cumberland, Rhode Island. Mr. Stephen Staples requested permission from the town council to dig up one daughter to "try an experiment" designed to save another daughter who had fallen ill. We can only guess as to the nature of that experiment, but it fits into a pattern that developed thereafter.

The next vampire is one of the more famous in Rhode Island. It is the well-documented case of Sarah Tillinghast. In 1799, Stuckley "Snuffy" Tillinghast has a dream. In his dream, he was working in his orchard. He heard his nineteen-year-old daughter, Sarah, call to him. He turned to search for her, but she was not there. When he turned back to his orchard, half of his trees had withered and died suddenly. At the time, he simply dismissed the dream.

Shortly thereafter, Sarah became ill. Doctors could not pinpoint a cause or a cure. They called it consumption, the wasting disease. Mysteriously, Sarah's life seemed to drain from her until she was dead.

One by one, Snuffy's children became ill. Doctors were powerless to save them and, one by one, they died. They each grew weaker and weaker and, just before the end, they began to cough up blood. They each also claimed that Sarah was visiting them in the night. She touched the children on the chest, causing them pain. After six children died and a seventh child took ill, the townsfolk finally convinced Snuffy that he must do something.

Snuffy was at his wit's end, distraught over the sudden loss of so many children and desperate to protect the rest. Doctors could not help, but legend offered a remedy. Local legend taught that vampires appeared, usually preceded by a dream. Vampires touched the chests of their victims and drew the life force out in their breath. Finally, the victim coughed up blood and died so that the vampire did not.

New England vampire legends tell that vampires could take the form of any animal, particularly crows, ravens, buzzards and cats.

Snuffy and his farmhands ventured to the cemetery and exhumed the bodies of Sarah and her siblings. When Sarah's coffin was opened, an audible gasp rose up from the men. Though she had been the first to die, her body was not decayed like the others. Her hair and nails had grown and her eyes were open and clear, staring skyward. Her lips were curled into a sinister smile. Knowing what he must do to protect his surviving family members from the vampire, Snuffy cut out his own daughter's heart, spraying everyone with fresh blood in the process. The heart was taken to a nearby rock and burned. The ashes were mixed with herbs and given to the sick child on the spot as an elixir. It was too late; the child died shortly afterward.

However, proving that they had done the right thing, no other children fell ill after the vampire had been so gruesomely slaughtered. It was only then that Snuffy's prophetic dream made itself clear to him. In the end, Sarah's voice had distracted him as he lost seven of fourteen children—fully half of his orchard.

The next vampire appeared in Foster in 1827. Captain Levi Young sensed a familiar pattern as members of his family fell ill to a mysterious disease. The remains of his daughter, Nancy Young, who was also nineteen, were

exhumed, the heart was burned and the family inhaled the fumes of the burning heart to protect them. Four more of the eight children died before the end.

Next was Peace Dale in 1874. William Rose suspected that his daughter Ruth Ellen Rose was a vampire. In a ceremony that was all too common in Rhode Island, the girl's body was exhumed and the heart was burned.

Our next vampire is a far more recent legend, that of Nellie Vaughn. She died in 1889 at the tender age of—you guessed it—nineteen. She was buried in her hometown of West Greenwich. She was not accused of being a vampire until the latter half of the twentieth century. At this time, a Coventry High School teacher was sharing the story of Mercy Brown with his class. To prevent them from disturbing her grave, he left out most of the identifying details—except her age. Students desperate to visit the grave of a vampire instead found the grave of poor Nellie. Her death fell in the same timeframe as Mercy Brown, who died in 1892, and her age matched. The most incriminating evidence against her was the inscription on her headstone: "I am waiting and watching you." As if that weren't enough to terrify students, the area above her grave was devoid of vegetation. No grass, moss or weeds grew in this one spot in the cemetery.

She became an instant vampire legend in Rhode Island. The mix-up brings many people to her grave. One woman went to the grave to photograph it. She found a woman alone in the cemetery. The woman was dressed oddly and stayed away from her as she photographed the grave. When she turned to leave, the strange woman abruptly approached her. "Nellie," she said, "is not a vampire." When she had the photos developed, she found that the pictures of Nellie's grave were reversed, though the other photos on that roll were fine.

Others have reported seeing a woman in Victorian dress hovering around the grave, nervously pulling her hair. She is often described as floating above the ground and then vanishing into thin air. Many report hearing a soft woman's voice that says simply, "I am perfectly pleasant."

The cemetery became a haunt for local students. Today, it is popularly called "Vampire's Graveyard," which you get to by passing through "Hell's Gate" and parking at "Satan's Church." Of course, Hell's Gate is merely a stone millwheel that is being used decoratively. Satan's Church is nothing of the kind—it is simply the historic Plain Meeting House Baptist Church. Unfortunately, the living are far more destructive than the dead. Vandalism to the cemetery and the church became rampant. Someone broke into a crypt. The worst incident came in 1993, when vandals dug up a coffin.

To protect Nellie and the property, her headstone has been removed. Today, grass grows thick and green on the spot where her grave, still

Visitors still leave coins for Mercy Brown, helping to pay her passage to the afterlife.

unmarked, remains. There is no way to know where to find it unless you already know where to look. Nellie's spirit seems to be at rest, now, though she still is waiting and watching.

MERCY

> *The innocent and the beautiful have no enemy but time.*
> *—William Butler Yeats*

There are dark places in our hearts where we dare not go. Deep inside, we fear the unknown on a primal level. It is our knowledge that most often shelters us from that fear. One of Rhode Island's strangest tales comes from the rural town of Exeter. It was here in 1892 that Mercy Brown became a legend. It is a tale that accentuates the harsh living conditions of rural life in early America. It showcases the fear and ignorance of an uneducated population. It serves as a warning to us all of what depths we can achieve if we allow fear and ignorance to dictate our actions.

Poor Mercy Brown was accused of being a vampire by those whom she loved most. Modern medicine tells us that the more likely cause of Mercy's condition was tuberculosis. In her day, this would more commonly be known as consumption or "the wasting disease."

Consumption began slowly, with a shortness of breath that became steadily more pronounced as the bronchia swelled. Fever and night sweats wracked the body. Her appetite faded and the chest felt crushed by pain from the lungs. As the lungs failed, the blood could no longer get oxygen. The skin became pallid and clammy. Victims of consumption weakly coughed up dead lung tissue and dark blood. The damp, cold air of the night often brought death to the long-suffering victim.

Unlike vampires of modern cinema, the New England vampires did not suck blood from the neck. Rather, they sucked the life force out of the victim through their breath. Vampires were often accompanied by premonitions and dreams of death and decay. Those being attacked by vampires exhibited symptoms that included a feeling of heaviness in the chest. Victims did not die quickly, but slowly wasted away as their life forces were drained. Skin became pale. They became unable to rest or eat, as they were exhausted from constant vampire attacks. Eventually, blood appeared around the mouth from the intense strain of the life force being sucked out in their breath. After death, a vampire showed growth of hair and nails. Blood appeared fresh, especially around the heart. Most telling of all, there would be little or no decay to the body.

Mercy Lena Brown was born in 1873 to George and Mary Brown. George was a simple horse trader and farmer living in the very rural community of Exeter. Her friends knew her as Lena and she died young, like many in her family. The first to go was her mother, Mary Eliza Brown, in December 1883, followed within two years by Mercy's sister, Mary Olive Brown. Her brother became ill in 1891 and was sent to Colorado, where it was hoped a "change of air" would help him to recover. Shortly after, Mercy fell ill with "galloping" tuberculosis and died relatively quickly on January 18, 1892, at the age of nineteen.

Eighteen months after leaving Rhode Island, Edwin Brown's health improved and he returned home. Once home, he immediately fell ill once again. He grew weak and pale. Fevers and night sweats tormented him through the night. One morning, he told his father that he had been visited by Mercy during the night. He claimed that she had touched his chest, causing him great pain. It was at this time that he began to cough up blood.

When the townspeople heard of Edwin's dream, they were certain that a vampire must have been attacking the Brown family—and perhaps others in the town as well. They insisted that something be done. Against the objections of George Brown, who could never accept that his daughter was a vampire, the townsfolk went to the Chestnut Hill Cemetery. Accompanying them was the town doctor, Dr. Metcalf, of Wickford. Like many citizens of

The Keep was used to store bodies while waiting for the ground to thaw for burial. Mercy's mother and sister were exhumed from their graves; Mercy's body was in the Keep.

Mercy's heart was cut out and taken to this rock, where it was burned to ashes.

the day, he was skeptical and went simply to calm the fears of the ignorant populace.

The bodies of Mary Eliza, Mary Olive and Mercy Lena Brown were exhumed on March 17, 1892. As one might expect, the older bodies were suitably decayed. Those in attendance at the gravesite were shocked to find that Mercy's body showed no sign of decay! Her hair and nails appeared to have grown. Most telling of all, when Dr. Metcalf cut into her, he was shocked to find fresh blood in her veins, especially around her heart. The skeptic became convinced. Mercy's heart was removed to kill the vampire. It was taken to a nearby rock and burned to ashes on the spot. Using a familiar recipe to the vampire-weary citizens of Exeter, the ashes were mixed with herbs and water to make an elixir. Edwin drank the elixir of his sister's ashes in a last-ditch effort to save him. Unfortunately, it was too late for the young man. He died on May 2, 1892.

A more progressive attitude recognizes that as a body decays, the flesh shrinks back slightly, giving the nails and hair the appearance of new growth. From our advanced position, we might immediately recognize that a body stored in an icy keep in January would still be fairly well preserved by March, when winter's grip has only barely released the cold cemetery. Even in 1892, Dr. Metcalf and the people of Exeter were considered ignorant, backward rubes.

When tales of their actions reached more urban areas of Rhode Island, it caused shock and outrage. Politicians spoke out against them and newspapers derided and chastised them for their ignorance. More enlightened, civilized people were appalled that even as they were perched at the edge of the twentieth century, such ignorance could still be found in the dark corners of society.

The *Providence Journal* ran an editorial regarding the incident. The article was picked up by the *New York Times*. From there it made its way into the hands of two influential horror writers. H.P. Lovecraft is widely recognized as the father of the modern American horror story. He lived most of his life in Providence and was very familiar with the Mercy Brown story. He borrowed heavily from the incident to write the short story "A Shunned House" in 1924.

Bram Stoker published *Dracula* in 1897 and defined the modern vampire legend. He studied vampire legends from around the world. He immersed himself in the fears and horrors of the peasants of Europe to combine their dark legends into one bone-chilling novel. After his death, the *New York Times* article about Mercy Brown was discovered in his paperwork. Indeed, the legend of sweet Mercy Brown remains truly undead.

Mercy Brown was, in fact, the last American vampire. Her father finally passed away in 1922. The fate of his two surviving daughters is unknown.

George Brown, Mercy's father, never accepted the theory that his daughter had been a vampire. He died in 1922.

While Mercy became immortalized as the last vampire, her surviving family members slipped quietly into oblivion.

FINAL BATTLE

The sea rises, the light fails, lovers cling to each other, and children cling to us. The moment we cease to hold each other, the moment we break faith with one another, the sea engulfs us and the light goes out.
—James Arthur Baldwin

U-853 was a German submarine patrolling the Atlantic during World War II. She was being hunted by the USS *Croatan*, which had just sunk two other subs. *U-853* proved so elusive that the Americans dubbed her *Moby Dick*. The hunt took a huge toll on the crew. When they returned to port, the captain and a large portion of the crew were declared unfit for duty.

It was a new captain and crew that took *Moby Dick* on her final patrol. She appeared off the coast of Maine on April 23, 1945, where she sank the USS *Eagle*. Her next attack took place off Point Judith, Rhode Island, on May 5, 1945. Hitler was dead by this point and the German commander in chief of

The Brown family rests together in the shade of a cedar tree at the Cedar Hill Cemetery in Exeter.

submarines, Karl Donitz, had ordered a cessation of hostilities, saying, "You have fought like lions." *U-853* never received the message. Hours later, she attacked and sank the SS *Black Point*, which sank with twelve fatalities. The *Black Point* was the last U.S.-flagged ship sunk during World War II.

Moby Dick was finally trapped. When she was found hiding at the bottom of the sea in eighteen fathoms (thirty-three meters) of water, several U.S. ships pounded the area, dropping more than a hundred depth charges. On May 6, oil slicks indicated that the submarine was at least wounded, and more depth charges pummeled the sea floor. Finally, planking, life rafts, a chart tabletop, clothing and an officer's cap floated to the surface. Divers confirmed the destruction of *U-853*. The final naval battle of the European front came after the war was officially over. Fifty-five officers and men died aboard the sub, simply because they had not gotten the message.

The sub is still there, off the coast of Newport, mostly intact and upright. It is considered a military graveyard, so divers are forbidden from taking artifacts. It is a deep dive, intended for the experienced diver. As with any shipwreck, there are great dangers involved in entering the submarine. Still, many divers cannot resist. There are stories, however, of ghosts under the sea. The spirits of the German sailors are believed to still haunt their final

resting place. Divers have heard strange noises at the bottom of the sea that seem to emanate from the wreck. Others have reported feeling that there are spirits around them. It is a pretty powerful feeling knowing that the corpses of the sailors are still inside the submarine and have even been spotted by divers. Not every graveyard is on land in the City by the Sea, and not every ghost is above the waves.

SALEM WITCH HUNT

Thou shalt not suffer a witch to live.
—Exodus 22:18

There were many differences between Newport and nearby Salem. Newport had been founded by refugees seeking asylum from Puritanical beliefs. Though they had brought a secular government to Newport, they maintained many of the same beliefs. Both communities were heavily influenced by the supernatural.

In both communities, courts allowed spectral evidence, such as dreams and visions. It was spectral evidence that convicted Thomas Cornell of murder in 1673. Less than twenty years later in Salem, spectral evidence would be used on a more grand scale, resulting in nineteen executions. As many as two hundred people were jailed for witchcraft and eighteen of those died in prison.

The Salem witch trials of 1692 were so brutal that they have defined the city to this day. From June through September, hysteria swept through the town of Salem. Hundreds of citizens were accused of witchcraft. One elderly man refused to submit to the trial and was pressed to death under heavy stones. The nineteen who were found guilty of witchcraft were carted to Gallows Hill and hanged. Denied Christian burials, they were dumped unceremoniously in shallow graves. Afterward, their families may have retrieved their corpses under cover of darkness to bury them in unmarked graves on family property.

The witch trials were lead by Jonathan Corwin and John Hathorne. One of the accused panicked and admitted to witchcraft and to meeting Satan. Soon, others began to see confession as a way to avoid the gallows. More and more witches were implicated in the hunt. Several of the accused were targeted by officials because of their non-conformist attitudes.

One woman complained about being overcharged by carpenters from Boston. Since she had made the complaint rather than her husband, she was seen as a dangerous radical, potentially in league with the devil. Old quarrels became the basis for deadly accusations. Often, the accusers were

Above: The Witch House in Salem was home to Judge Jonathan Corwin, one of the judges who convicted witches in 1692.

Left: Elizabeth Montgomery is immortalized in Salem, offering welcome to witches and their admirers today.

less affluent than the victims, indicating a motive of jealousy. Many accusers benefited financially from the death of their victims.

Eventually, the witch hunt came to an end. By autumn, Salem's bloodlust had subsided. Many judges eventually issued apologies, in one form or another, for "errors in judgment." William Stoughton, more than any other man, was responsible for the scope of the witch hunt. He never did apologize for his role in the trials. Instead, he criticized others for interfering just as he was about to "clear the land" of witches.

Thanks to the attempts to rid Salem of witches, a witch culture has sprung up there. Today, there are Wiccan groups, magic shops, museums and all sorts of stores that capitalize on Salem's link to witchcraft. The city has cultivated its witch heritage and has attracted a large number of residents and visitors interested in witches. There is even a statue of Elizabeth Montgomery, commemorating her career on the TV show *Bewitched*. The Puritans may just have been better off to leave their witches alone, for they have done more to promote witchcraft than any other group.

Newport Literature

Literature is the art of writing something that will be read twice;
journalism what will be grasped at once.
—Cyril Connolly

Newport has been particularly influential on pop culture. As a resort destination, it has attracted many of our nation's influential writers and producers. As a picturesque location, it has inspired many artists and been the setting for films. Rhode Island has proven to be an inspirational medium to many—notably some of our earliest horror writers.

The story of Mercy Brown, as has been mentioned, was one of Bram Stoker's inspirations as he wrote *Dracula*. In itself, that is a pretty important contribution to the horror genre. However, Rhode Island has an even more direct link to the greatest American horror writer, Edgar Allen Poe.

Poe lived briefly in Providence, where he fell in love. He became engaged to Sarah Helen Power Whitman (1803–1878), a local poet. He wrote two poems in her honor, *To Helen* and *Annabel Lee*. She is best known as his fiancée. Her most famous works—*Edgar Poe and His Critics* and her compilation *Letters of Edgar Allen Poe to Sarah Helen Whitman*—are about the man she nearly married. Unfortunately for the two, Poe's alcoholism appears to have brought about the failure of the relationship. Poe left Providence at the end of their engagement.

One native Rhode Islander is credited with creating the modern American horror story. H.P. Lovecraft (1890–1937) became familiar with

tragedy at a young age. Both his father and grandfather died when he was young, bringing him from a life of affluence to a modest lifestyle in Providence's Upper East Side. He suffered a nervous breakdown at an early age. In fact, insanity haunted him and his family for most of his life. Most of the members of his immediate family died in the local mental institution.

In 1913, Lovecraft became interested in the emerging popularity of pulp fiction. Once, upon reading a piece that he felt was truly horrible, he began barraging the publisher with letters. This began a lifetime of correspondence and introduced Lovecraft to publishing.

He began writing for a magazine called *Weird Tales*, and in 1924, married Sonia Haft Greene. The couple divorced in 1929 and he formed Arkham House Publishing with two friends. In 1939, *The Outsider and Others* became the first of his books to be published in hardcover. One of his other well-known works is *The Call of C'Thulu*. His work is heavily influenced by the mysterious New England coastline, by insanity and mass hysteria and by the Puritanical attitudes that permeated the culture in Rhode Island. He, in turn, inspired the next generation of horror writers and elevated the genre to an art form that it rarely has achieved since then. Today, his books remain popular and frightening. His grave is the most popular attraction at the Swan Point Cemetery in Providence.

Of course, the area has produced more than just horror. The first woman ever to receive the Pulitzer Prize was Newport resident Edith Wharton (1862–1937). Edith purchased the cottage Land's End in Newport and took an active role in redesigning and redecorating it. In 1897, she wrote *The Decoration of Houses*, with architect Ogden Codman. She wrote extensively at Land's End in Newport, though her most famous work is the novel *The Age of Innocence*, which she wrote in 1920. Set in New York City, it is an examination of the upper-class morals and values. It earned her the Pulitzer Prize for fiction.

Newport appears in countless books, movies and television shows. The wide array of settings attracts filmmakers to the area to shoot scenes. Spielberg filmed much of *Amistad* in Washington Square and at the Old Colony House. *The Great Gatsby* and *True Lies* were both partially filmed at Rosecliff. The Rhode Island Film Commission actively courts big-budget films to the area with tax breaks and other incentives. Filming has recently been done for Disney's *Underdog*, the motion picture *Evening*, Showtime's series *Brotherhood* and many more. It appears that Newport and Rhode Island will continue to have artistic influence and cultural relevance beyond their small size. The natural scenery and the fierce determination continue to serve the area well.

Newport has beautiful scenery, panoramic views, art and architecture—and a dark side as well that helps make it a great setting for books, movies and photography.

The Station

Hope.
—Rhode Island state motto

Words cannot express the scope of the tragedy of the Station Nightclub. On February 20, 2003, a pyrotechnics display at a Great White concert ignited foam insulation in the nightclub. The Station was operating illegally without a sprinkler system. It was far in excess of its legal occupancy limitations and the walls were coated with sound insulation manufactured from petroleum.

Club owner Jeffrey Derderian had been a newscaster and had done a story about the dangers of foam mattress pads. He referred to it as "solid gasoline." In spite of his report, it was the same foam mattress pad material that was added to his nightclub as sound insulation. Additionally, reports indicate that the ceiling was painted with flammable tar. As the building burned, flaming tar and burning plastic ceiling tiles poured onto the hundreds of people inside. Thick, black smoke laced with hydrogen cyanide and other toxins filled their lungs. Inadequate exits trapped many.

Within three minutes of the display, one hundred people were dead or dying and nearly three hundred were injured. It was one of the worst nightclub disasters in American history. The site, on Cowesett Avenue in West Warwick, Rhode Island, is a fresh memorial to the victims who died there. The memories begin to fade for some, but the loss is too great for others. Mothers, fathers, children and siblings were lost in the blaze.

An inept attorney general has failed to provide justice for the victims. The courts are still filled with lawsuits. Unfortunately, legal wrangling will serve to benefit the lawyers more than the victims of this crime. The club's insurance will pay only a small amount of damages; the club did not even have the required workman's compensation insurance to pay employees. The victims—injured survivors and families who lost loved ones—need support. Please make donations through www.StationFamilyFund.org.

If there are ghosts in the world, they are here at the site of the fire. One woman claims that she was sickened by repeated visits from her mother's ghost, each night getting more and more frantic. The desperate visits made her so sick that she backed out of the trip to the concert. Her friends went without her. None of them survived.

One victim saw the spirits of his grandmothers as he was trapped inside the blaze. They told him not to give up, that it was not his time. Although he had resigned himself to death, he sought escape with renewed purpose. The spirits seemed to lead him to the exit, where he was able to escape after suffering severe burns.

There is a palpable heaviness to the site of the fire. An indescribable feeling permeates the makeshift memorials. The stories I have related in this book come from this same sense of grief. Are they real or imagined? The answers will one day come for us—all too soon. If there's a lesson to be learned, it is to live life, love living and to not be afraid to tell the stories.

I dedicate this book to all of the people who were touched by the tragedy of the Station Nightclub Fire.

To help victims of the Station nightclub fire, please contact www.StationFamilyFund.org.

Spirit Guide to Newport and Vicinity

You know I must've got lost
Somewhere down the line.
—*J. Geils Band*

Astor's Beechwood Mansion
580 Bellevue Avenue, Newport
(401) 846-3772 or www.AstorsBeechwood.com

Firehouse Theater
(401) 849-FIRE or www.FirehouseTheater.org

Hotel Viking
1 Bellevue Avenue, Newport
(800) 556-7126 or www.HotelViking.com

International Tennis Hall of Fame
(401) 849-3990 or www.TennisFame.com

Jailhouse Inn
(800) 427-9244 or www.JailhouseInn.com

Newport Art Museum
76 Bellevue Avenue, Newport
(401) 848-8200 or www.NewportArtMuseum.com

Newport Historical Society
82 Touro Street, Newport
(401) 846-0813 or www.NewportHistorical.org

Newport-Jamestown Ferry
(401) 423-9900 or www.ConanicutMarina.com

Old Town Ghost Walk
(866) 33GHOST or www.GhostsOfNewport.com

Pilgrim House Inn
123 Spring Street, Newport
(800) 525-8373 or www.PilgrimHouseInn.com

Preservation Society of Newport County
(401) 847-1000 or www.NewportMansions.org

Redwood Library
10 Redwood Street, Newport
(401) 847-0292 or www.RedwoodLibrary.org

The Rhode Island Paranormal Research Group
www.triprg.com

Rory Raven
www.RoryRaven.com

Rose Island
(401) 847-4242 or www.RoseIsland.org

Stevens Shop
29 Thames Street, Newport
(401) 846-0566 or www.JohnStevensShop.com

Valley Inn
2221 West Main Road, Portsmouth
(401) 847-9871

White Horse Tavern
26 Marlborough Street, Newport
(401) 8549-3600 or www.WhiteHorseTavern.com

Yesterdays
28 Washington Square, Newport
(401) 847-0116 or www.YesterdaysandthePlace.com

About the Author

"Last words are for fools who haven't said enough!"
—last words of Karl Marx

John Brennan is a Newport resident and tour guide. He has been a guide for Ghost Tours of Newport as well as aboard the M/V *Spirit of Newport*. He is a history buff with a particular fascination for local history. A Swamp Yankee who accidentally crossed the bridge over a decade ago, he has made a home in Newport's Fifth Ward. He can be found at various "haunts" throughout Newport, swapping stories and spirits with locals and visitors. John is an award-winning actor who has appeared on stage, television and film. His photos have appeared in newspapers, magazines and on Jones Soda bottles. As busy as he is, his most important job is his family—his wife, Michelle, and his children, Michael, Mackenzie and Bailey.

Please visit us at

www.historypress.net